video art

SYLVIA MARTIN
UTA GROSENICK (ED.)

TASCHEN

KÖLN LONDON LOS ANGELES MADRID PARIS TOKYO

contents

moving pictures

At the beginning of the 21st century, video is a familiar medium. Video is a phenomenon well-known to everyone, including the comfortable hand-held camera and video cassette recorder in one's own household, surveillance systems in buildings and public places, commercially available videotape, and animated images projected in museums. Thereby the standard of knowledge about the technology behind video, about the flow of images produced with it, and about its associated culture remains rather rudimentary – particularly with regard to the field of Video art.

When video established itself in the art context at the end of the 1960s, cinema had meant that viewers' perceptions had already become accustomed to moving pictures for more than half a century. Public and private television stations had been making their programmes available to audiences throughout Europe and the USA since the 1940s and 1950s. Moving pictures and their electronic transfer were therefore a well-tried media construct.

However, video differs from its two closest relatives, film and television, in one essential point: it directly translates the audio-visual material into analogue or digital code. Thereby, recording and storage take place synchronously. Video is a means of preservation that retains the recorded material in a state of permanent availability and manipulability. In contrast, traditional film is a sequence of individual images visible on the celluloid to the naked eye, and only the mechanical movement of the length of film during projection produces the movement. On mag- netic tape, laser disc, or some other storage media that may be used for video, neither the pictures nor the bits of encoded information that make up the images are recognizable. Unlike film, video dissociates itself in a further technical step from directly illustrating reality.

Technological innovations permanently change the hardware. While both a hand-held camera and a magnetic tape recorder were initially necessary, today videos can be produced and edited entirely on a computer. The digital flow of data from our media society provides an inexhaustible pool of material, which is available for use and further manipulation. Now also equally uncertain is the video's final appearance – the form in which it will present itself: the possibilities extend from the gigantic screens in New York's traffic-clogged Times Square, to the types of monitors commonly available in stores, all the way to the miniature screens of mobile telephones. Video is like a chimera that can assume many appearances.

Artists who work with video confirm the medium's changeable nature. Thus Nam June Paik, one of the "electronic" pioneers, understood video as a model of life. In 1980 Bill Viola recorded in his notes: "No beginning/No end/No direction/No duration – Video as mind." In another interview, three artists of the younger generation gave responses to the question, "So what characterizes video as a medium for you?" Anri Sala: "Time code." Ann-Sofi Sidén: "Simple ideas presenting themselves in an instant, but followed by an intense or expansive period of production, and in the end resulting in long hours in

1965 — Sony releases the first portable video recorder, Portapak video-recorder and shows the first artistic videotapes at a party in New York on September 29

1965 — Andy Warhol is presented with a Norelco slant-track-

"we live in a reality with structures definded by the inventions of the mass media – printed and electronic images are the building blocks of our cultural evolution."

Aldo Tambellini

1

front of the computer watching, editing, reviewing." Mark Leckey: "4, 3, 2, 1, blast-off! 4 for the moments of love, 3 for the stages of life, 2 for black and white, 1 for monochrome and color, cinema and video, TV and life, Hitler and [Simone] Weil, Spielberg and Godard."

Even in the first half of the 20th century, artists had become preoccupied with electrical transmission devices. Thus in the 1930s the littérateur and founder of Italian futurism Filippo Tommaso Marinetti recognized radio as an organ that could bridge great distances and reach a mass audience. Moreover, he saw the combination of theatre and television screens as a practicable model for the future. To the same degree that Marinetti enthusiastically welcomed the new media, the German man of letters Bertolt Brecht was critical of it. In the same era, and considering also the example of radio, Brecht pointed out the risk of enforced conformity and indoctrination. This kindled a discussion of the media at an artistic level, which has continued in philosophical and sociological circles to this day. Thereby video is debated in the context of various disciplines such as media theory, art history, or philosophy. Moreover, since the 1990s the image sciences have been examining the increasing significance of images in society, culture, and communication – one speaks of the iconic and pictorial turn.

Since the 1970s the communications scientist Vilém Flusser has dealt dedicatedly with the phenomenon of video in a few short texts, finally defining it in 1991 as a "dialogical memory". Only a year

earlier, based upon the video installation *Disturbances (among the jars)* by the artist Gary Hill, the French philosopher Jacques Derrida championed the viewpoint that Video art must first be considered in relation to conventional artistic languages. Again and again theoretical considerations such as this and others converge on the incomprehensibly "reflexive" (as Yvonne Spielmann calls it in her 2005 publication) character of the medium of video and underline its position as a hybrid inter-medium.

The 1960s

In the second half of the 1960s Video art came of age among artists who, under the banner of intermediality, broke with conventional genre notions. With his drippings at the end of the 1940s Jackson Pollock had introduced a performative approach to painting. At the same time, the composer John Cage integrated chance and tape-recorded non-instrumental sounds and noises into his scores. In 1959 Allan Kaprow invited the public to his *18 Happenings in 6 Parts* at the Reuben Gallery in New York. Generally seen as the founding event of the Fluxus movement, the Fluxus Festspiele Neuester Musik (Fluxus Festival of Newest Music) took place in Wiesbaden in 1962, with the participation of artists such as Dick Higgins, George Maciunas, Nam June Paik, and Wolf Vostell.

--
1965 — Nam June Paik buys one of the first obtainable Portapaks in the USA, and soon afterwards shows the tape "Electronic Video Recorder" in the New York Cafe Au Go Go
--

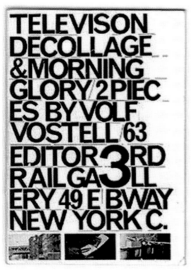

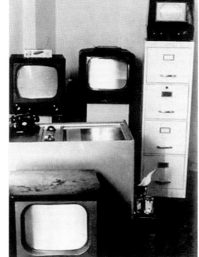

"Just as collage has outsted oil painting, so the cathode ray tube will replace the canvas."

Nam June Paik

2. + 3. WOLF VOSTELL
Television Décollage
1963, left: pamphlet of two Happenings performed at the 3rd Rail Gallery and the Smolin Gallery in New York; right: exhibition in Smolin Gallery, New York

2

3

The interdisciplinary crossover between the plastic arts, literature, music, dance, and theatre, as well as a lively international exchange of ideas, created a broadly based cultural climate in which new technologies were used experimentally, and their suitability for artistic expression tested. Video's development was now marked by a fascination with the expanding field of television, the electrotechnical affiliation to which fostered the new medium's beginnings.

In March 1963 the trained composer Nam June Paik installed his "Exposition of Music – Electronic Television" in the architect Rudolf Jährling's Galerie Parnass in Wuppertal. Paik combined twelve prepared television sets with four pianos, record players, tape recorders, mechanical sound objects, and the head of a freshly slaughtered ox that hung over the entrance to the space and, as a cleansing initiation zone, had to be passed by visitors. The exhibition ran for only 14 days with moderate success. Since German channels, unlike American television, only broadcast in the evening, the gallery's opening hours were shifted to evenings.

Paik used technical interventions to modify the transmitted electronic images. One of the televisions among those scattered throughout the showroom was connected to a tape recorder, for example, through which music was fed into the set. The sound recording's electronic impulses influenced the likewise electronically produced image on the monitor. Another screen displayed merely a single vertical line: *Zen TV*.

At the same time as this, in the years 1962 to 1964, artists such as Tom Wesselmann, Günther Uecker, Isidore Isou, and Karl Gerstner discovered the television set as artistic material. While Paik exploited in a structural sense the possibilities of electronic data transfer and its appearance as an apparatus, Wolf Vostell's so-called television decollages represented an obviously critical position towards the nascent television hegemony. In a show entitled "Wolf Vostell & Television Decollage & Decollage Posters & Comestible Decollage" running from May to June 1963 in New York's Smolin Gallery, he exhibited, among other works, six television sets showing different programmes. The picture was decollaged, meaning that it was created through an aggressive act: in this case through image interference. Vostell had coined the term "decollage" in the 1950s to contrast with collage, a process built up layer by layer. In this phase, following Raymond Hains and Mimmo Rotella, he worked with torn posters (which in art history are also known as decollages). In the Smolin Gallery Vostell transferred the principle of decollage to electronic television sets, which he additionally combined with canvasses, objects, and food, including grilled chicken.

At the end of the 1960s, in the context of the general mood of social renewal, artists took an instrumental, idealistic approach as a means of extending this modulating, material use of television. They now went "on air" and attempted to agitate artistically within television's own economic structures. They wanted to reach a mass audience of consumers, and thereby to connect art and life on a media

1966 — The first video game is developed by engineers from the company Sanders Associates in New Hampshire
1967 — Aldo Tambellini opens the Black Gate, the first "electro-media theatre", in New York, where he arranges performances

4.
Opening of the first TV exhibition
"Land Art" in Studio C, Sender Freies Berlin
(SFB), 28 March 1969; left: Jean Leering,
right: Gerry Schum

4

level. In 1967 the public station WHGB-TV in Boston set up an "Artist-in-Television" programme, of which an outstanding result was the broadcast, two years later, of *The Medium is the Medium*: Allan Kaprow, Nam June Paik, Otto Piene, and Aldo Tambellini, among others, produced a mixture of video, dance, theatre, and television, and transmitted their work into domestic living rooms.

In 1969, in Germany the public service broadcaster Sender Freies Berlin (SFB) included in its programming the Fernsehgalerie (television gallery) founded in Düsseldorf by Gerry Schum. Schum worked closely with Richard Long, Dennis Oppenheim, Robert Smithson, and Walter de Maria, among others, and without any commentary he broadcast the 38-minute tape *Land Art*, created within this co-operation. Moreover, at the beginning of the 1970s in the USA, an underground video movement arose around the magazine "Radical Software". This movement was called *Guerrilla Television*, and its programming was directed against mainstream television. Doug Hall with his *TV Interruptions* (1971) and Chris Burden with *Promo* (1976) then joined the list of artists who worked with television at an instrumental level.

It was not only during the early years, however, that video and television enjoyed a productive exchange. The dialogue, be it critical and agitational or appropriating and experimental, continues to this day. Television itself had meanwhile developed into a hybrid construct, in which one could only with difficulty distinguish between information and entertainment, documentary and fiction. A young generation of artists well-experienced with television commented upon this infotainment, or exposed with irony the workings of global television's range of programming.

In Pipilotti Rist's 1994 video installation *Das Zimmer* (The Room) the user shrank among colossally enlarged living-room furniture to a naive and childlike body size. Thus the abnormal proportions reduced seated viewers, gazing at a normal-sized monitor, to the image of naive consumers. While the television set has here been updated to become an art object, in *Fishtank* (1998) Richard Billingham adopted the format of Reality TV. The British artist recorded his family's daily lives on video for three years. The artist himself, his alcoholic father, corpulent mother, and unemployed brother formed an apparently hopeless community, living together in the closest of quarters. *Fishtank* was broadcast on television by BBC2 on December 13th, 1998. The audience was embarrassedly touched and voyeuristically attracted.

The German artist Christian Jankowski went a step further with his work *Telemistica*, presented at the 1999 Venice Biennial, by intervening in the events of live fortune-telling shows broadcast on Italian television. He called the soothsayers during their programmes and questioned them in broken Italian about his success at the Venice exhibition. The programme filmed from the screen was the video piece, which in the art context reflected the television show's structure and function, but simultaneously took it to the point of absurdity.

--

and "environment actions" with video 1967 — The exhibition "American Sculptures of the Sixties" in
the Los Angeles County Museum of Art shows a video installation by Bruce Nauman

--

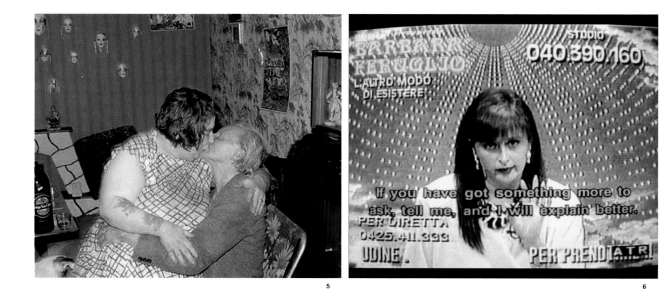

5 6

тechnology and image

Video depends upon the current state of technological develop-
ment more than almost any other artistic medium. The greatest change
since the emergence of Video art has been the step from analogue to
digital image production – a technical development that the art viewer,
however, can only comprehend with difficulty.

At the beginning of video history the relationship between tech-
nology and image was clearly defined. The camera transformed visual
information – the light coming through the lens – into electrical sig-
nals. Through cables, 25 pictures per second were sent directly to a
monitor, or for storage on magnetic tape. The standard for the Ameri-
can NTSC (National Television Systems Committee) was 30 pictures.

For storage in a recorder, the magnetic head changed electrical
signals supplied by the camera into a magnetic field, which in turn
magnetized the video's ribbon of film. When playing the tape this path-
way was reversed. The screen finally translated the coded information
into pulses of light. Every video image in the PAL (Phase Alternating
Line) system is thereby made up of 576 lines, built up line by line from
two half-images consisting of 288 lines each. In the American system
this is 540 lines, with 270 lines per half-image.

In 1967 Sony put the first analogue video device on the market.
The camera and sound recorder formed a portable unit, but consisted
of two separate devices. In 1971 the functions of the apparatus were

expanded to include playback, rewind, and fast forward, and in 1983
the so-called camcorder came onto the market, combining a camera
and sound recorder in one device. The storage medium developed cor-
respondingly from the ribbon tape to the U-matic cassette, then to
Betamax and VHS, which is certainly still common today, and to the
Video 8 cassette.

Nam June Paik, Les Levine, and the Pop art protagonist Andy
Warhol were among the artists who worked with the portable video
equipment immediately after it appeared. In New York's Café Au Go
Go in 1965 Paik presented his first tape showing images of the
pope's visit at that time, which he later recorded over. Succinctly and
somewhat questionably from today's point of view, Paik proclaimed:
"As collage technique replaced oil paint, the cathode-ray tube will
replace the canvas." In the same year Warhol presented his work
Outer and Inner Space (1965), taken with a cinematographic cam-
era and displayed from two rolls as a split-screen projection. One of
the four images shows a film sequence of the "Factory Girl" Edie
Sedgwick, and a second shows Sedgwick watching this film on a
monitor. Corresponding commentary from Sedgwick about herself
can be heard. Warhol used *Outer and Inner Space* to reflect upon
conditions of production, and allowed the images to enter into dia-
logue with one another.

At the end of the 1960s the new medium gained broad accept-
ance in the art world, although video equipment became available on

1968 — Jean-Luc Godard and Chris Marker use the first Sony CV-2100 ½-inch black-and-white recorder, to make raw documentary films
1969 — The Catalonian artists Joan and Oriol Durán Benet are the first ones to experiment with closed-circuit video (Daedalus Video)

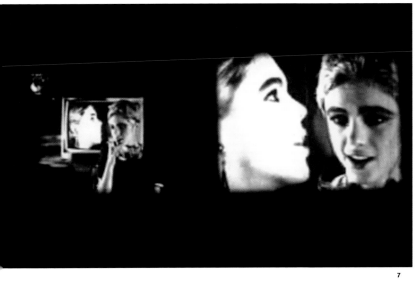

5. RICHARD BILLINGHAM

<u>Fishtank</u>
1995, film, 47 min

6. CHRISTIAN JANKOWSKI

<u>Telemistica</u>
1999, DVD, 22 min

7. ANDY WARHOL

<u>Outer and Inner Space</u>
1965, 2 black-and-white 16-mm films, sound,
each 33 min

7

he free market in Europe slightly later. While analogue video technology allowed real-time playback that could be edited after recording in terms of shot sequence, montage, and so on, it also made the production of synthetic image material possible. Even as electronic signals are input into the device, additional impulses can stretch, compress, or convert the image's linear structure into another form. As early as 1963 in his exhibition "Exposition of Music", Paik used magnets to distort the television image.

Since 1969/70, Paik (together with the technician Shuya Abe), Ed Emshwiller, Steina and Woody Vasulka, and also Eric Siegel have developed synthesizers that allow this type of direct image manipulation. Siegel designed a video synthesizer that kaleidoscopically expanded the electronic vocabulary. The Vasulkas used technical equipment to experiment with the 288-line half-image of the cathode-ray tube screen. In synthetic image production the picture on the monitor appears as a surface of variable energy, generally exhibiting a clear tendency towards abstraction. The electronic medium takes itself as its theme here, and the processes of image production normally hidden in the equipment become perceivable.

Even in the 1970s some artists began to use a digital approach to electronic image editing, and by the end of the 1990s the recording of audio-visual material on magnetic tapes was largely replaced by numerical storage in data sets. Now image production finally broke away completely from everyday reality and entered the field of simulation.

In 1997 Sony, followed by Canon, introduced the digital camera onto the American market. The device translated the recorded images into a binary code – a code based on only two numbers. The data sets were stored on laser disc, CD-ROM, DV cassettes, or DVD. Due to the numerical code upon which it is based, any kind of digitally recorded material can potentially serve as a usable source of material for further processing. The "copy and paste" function allows individual segments to be excerpted from an image and recombined; the technique of morphing allows a smooth transition from image to image; and so-called digital compositing makes it possible to seamlessly combine several elements into one picture. Video recording was now significantly expanded by using graphics programmes to produce computer-generated images.

Since the 1990s the video image has appeared in the art context primarily as a (wall) projection. For this purpose a DVD player generally sends the stored information to a beamer (video projector). Thereby the digital video image, made up of extremely small, continuously changing dots, is transmitted to the projector. These dots can be seen far more clearly in digital images than in analogue ones, as innumerable little pixels.

The technical process, whether analogue or digital, attests to the fact that the video picture is a procedural, non-discrete image type; the image is permanently in the process of forming or dissipating and doesn't show the film-reel's static single image. By the begin-

1969 — The exhibition "TV as a Creative Medium" is shown at the Howard Wise Gallery in New York
1970 — The first book about video art, "Expanded Cinema", is published in New York

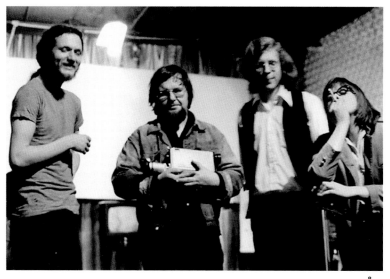

8

ning of the 21st century the computed, digital video image had largely replaced the analogue image, which was displayed in lines.

The 1970s

Amongst anti-war protests, the student movement, feminism, and the liberation movement of black America, Video art's initial phase had occurred in a period of social and political renewal, the impetus of which – critical, experimental, and simultaneously utopian – extended well into the 1970s. Artists expressing themselves in the most varied of artistic languages used the new technology under individual assumptions. Video remained an interdisciplinary medium that primarily appeared in the fine art context (Conceptual art, Body art, Land art, and Action art), and which also entered into a dialogue with the growing mass media (television, film, and radio). The conceptual development of models of time and space, as well as the human body as material, were major thematic emphases. As a technical system and producer of media images, video took a constitutive role here. Video feedback technology – described in the art context as a closed-circuit installation – became an important system by which artists reflected both upon themselves and the viewer's position, and also that of the electronic media. The live pictures transmitted by direct video feedback demonstrate their own structural system and counteract the illusionism of film and television. Stored recordings, on the other hand, are generally played as single-channel tapes on monitors, which create their own presence in the space.

The media images of the 1970s demonstrate an aesthetic quality that was conditioned by the technical possibilities of that time. The tapes display streaky, coarse-grained, and occasionally flickering images. Black-and-white pictures are overlaid by a grey veil, and the colour videos just beginning to appear exhibit an unnatural coloration. In the 1970s this blurriness went hand in hand with the immediacy the artists strove for; from today's viewpoint, if one thinks of unfocused photos in photo-journalism, or of the greenish night photos showing military action, the blurry look is occasionally intentionally produced to give the visual reports an air of authenticity. On older tapes it is the immature technology that produces these effects. In early video works the hand-held or static cameras, as well as roughly edited sequences, also greatly multiplied the overall impression of authenticity. Not until the second half of the decade did the montage become more refined, and technical effects such as fades and image-mixing became more common.

The first Video artists to use the new medium for artistic production without coming from another discipline now appeared to drive this electronic artistic language forward. Public forums for Video art arose even at this early stage, although they were few and far between. The 1969 "Television as a Creative Medium" in New York's

1970 — Stephen Beck builds the first direct-video-synthesizer
1971 — Gerry Schum opens his video gallery in Düsseldorf, two years after founding a TV-gallery in Berlin

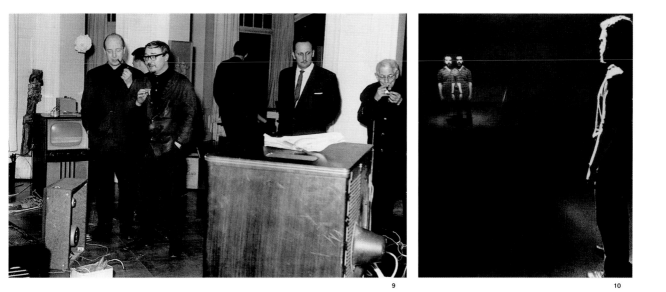

9

10

Howard Wise Gallery is considered one of the first thematic presentations. Two years later Howard Wise's "Electronic Arts Intermix" was set up as a sales organization for artists' videos. Further exhibitions and distribution forms followed. In 1970 the Everson Museum of Art in Syracuse (NY) showed the exhibition "Circuit: A Video Invitational"; in 1971 Steina and Woody Vasulka founded The Kitchen in New York, together with Andres Mannik; in 1972 the Museo Civico in Bologna presented "Video Recording", and in the same year the Neuer Berliner Kunstverein (NBK) founded the first video collection; and in Cologne in 1974 the gallerist Ingrid Oppenheim opened her video studio. In 1977 documenta 6 reflected the state of Media art in the video segment curated by Wulf Herzogenrath. The international video scene made an appearance in Kassel, representative work was accessible in a videothek under the slogan VT ≠ TV (videotape does not equal television), and the opening was broadcast live on television via satellite.

Body and performance

Since the end of the 1950s the concept of art has continually expanded its borders in various directions. Work with the human body (John Cage, Gutai, Yves Klein), Action art (Happening, Fluxus), and Joseph Beuys' dictum that everyone is an artist, have combined art and life into a single unit. For art and life actually to merge with each other, however, is an aspiration that can be achieved only with difficulty. Around 1970 some artists also renounced this asserted coalition. "The art context", as Vito Acconci said, "hasn't the rules real life has." The Action artists who followed developed a conceptual form of performance, which was largely independent of chance. They focused upon the body as aesthetic material, as a projection surface, and as an indicator of mental states. The technical medium of video now became a structural element in their actions. Tape-recordings and live transmission to a monitor both dematerialized the real body and allowed it to reappear as an image. "Am I a man, or am I a machine?" asked Jean Baudrillard in 1988.

In the first half of the 1970s some Action artists performed in their studios with no audience except the camera. In these cases the media image functioned as a narcissistic mirror and as electronic design material at the same time. It opened a window for viewers, and they gained access to an event that had already happened. Others equated the organic body with the camera, and perceived their environment from this bodily perspective (e. g. Dan Graham or VALIE EXPORT).

Video also fulfils a central media-related function in performances before an audience or in a public space. When Vito Acconci, for his action *Following Piece* (1969), followed randomly selected people in public places in New York at different times over a period of 23 days, then the recorded images documented not just a random

1971 — Steina and Woody Vasulka establish The Kitchen Live Audio Test Laboratory in New York for the presentation, production and distribution of art-works, mainly in the genre of video

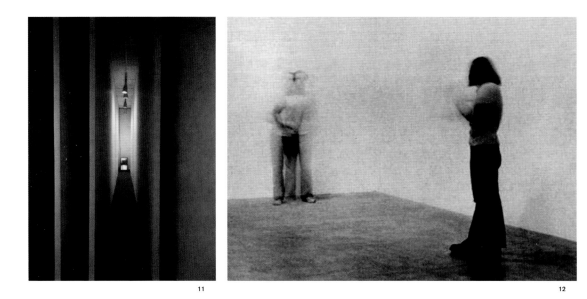

11

12

excerpt of socio-cultural structures and human behaviour, but also demonstrated the media categories of surveillance and the voyeuristic gaze, which were a significant aspect of the concept.

The two further poles which are performatively debated in videos dealing with the physical body are its behaviours when in pain, in danger, or when experiencing desire, and the depersonalized body experience in which the human body mutates into an apparatus. With *SHOOT*, Chris Burden carried out what was probably the most spectacular performance of the 1970s. On November 19th, 1971, a friend fired a 22 calibre weapon at the artist from a distance of four metres. The shot, which was only supposed to graze Burden, punctured his upper arm. The performance took aim at imagined fears: fear of pain, of being helpless, and of death, which had previously, in 1963, found its media counterpart in the − accidentally filmed − fatal shooting of American President John F. Kennedy.

In the context of the times, the Vienna actionists including Otto Muehl, Günter Brus, the writer-director Kurt Kren, as well as the artists Gina Pane, Marina Abramovic and Ulay, Smith/Stewart, Douglas Gordon, and others, explored these types of physical experiments that overstepped the barriers of pain. When, in the year 2000, Francis Alÿs carried a pistol with him on his videotaped walks through Mexico City *(Re-enactments)* and was arrested by police, not only was the real danger for the artist palpable in this situation, but the history of Media Action art was also present.

Which regards to the moment the shot was fired, Burden said that, at that instant, he had been a sculpture. With this statement he negated his emotions and approached the depersonalized conception of the body that artists such as Bruce Nauman, Dennis Oppenheim, John Baldessari, and Jochen Gerz explored more fully in the 1970s. In his early video works Nauman executed a predetermined series of movements in front of a static camera, mechanizing the body and allowing the subject and its idiosyncrasies to recede. Thus man is reduced to a biological organism. Only when the artist reaches his physical limits does his personality reappear and random occurrences creep back into the concept. Thereby the camera defines the framework of movement, and the space and excerpt shown of the field of action. Nauman occasionally emphasized the conceptuality of the action by placing the video camera sideways or upside down, thereby attaining a higher degree of abstraction in the image through the defamiliarization this achieved.

During the 1980s some artists, above all Paul McCarthy, turned away from this reduced form of body-related Action art and presented performative actions in their videos, which were somewhat reminiscent of the production formats and sets from the fields of film and television. Nonetheless, the body remains a preferred topic for artists to this day. Thus in his performances during the 1990s Santiago Sierra derived socially critical subject matter directly from the marked human body; other artists transported viewers by means of data gloves and

1972 — Sony launches the first portable colour video recorder and introduces a standard system for video cassettes
1973 — Flor Bex opens a video department at the Internationaal Cultureel

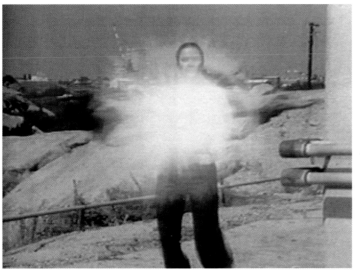

11. BRUCE NAUMAN

Live-Taped Video Corridor
1970, wall construction, 2 monitors,
camera, VCR, videotape,
variable dimensions, approx. 365 x 975 x 50.8 cm
Solomon R. Guggenheim Museum, New York,
Panza Collection, donation, 1992

12. CHRIS BURDEN

Shoot
1971, performance, F Space, Santa Ana, California

13. DARA BIRNBAUM

Technology/Transformation: Wonder Woman
1978/79, video, 5 min 16 sec

13

data helmets into cyberspace, and made possible a purely virtual experience of the body and of space.

The image of woman

With a spin of the body and an energetic flash of light, a normal woman transforms into a superwoman endowed with miraculous abilities in *Technology/Transformation: Wonder Woman* (1978). For her 7-minute tape Dara Birnbaum drew upon a television figure: Wonder Woman, a female counterpart to superheroes such as Batman, Superman, and Spiderman. The artist strung together sequences of her magical transformation, thereby raising debate about the image of women in society and in the media. Together with VALIE EXPORT, Lynn Hershman, Nancy Holt, Ulrike Rosenbach, Martha Rosler, Rosemarie Trockel, and Friederike Pezold, Dara Birnbaum belongs to the first generation of artists to use the medium of video to question the position of women in a patriarchally oriented media society. Such artists use the female body as a means of pointing out entrenched role models and patterns of behaviour.

With Roberta Breitmore, Lynn Hershman created a completely artificial figure whom viewers could variably redesign by means of interactive commands. In symbolically loaded performances Ulrike Rosenbach, who founded the working group "Schule für Kreativen Feminismus" (School of Creative Feminism) in Cologne in 1976, transformed her body into a projection surface both in the fanciful as well as in the actual sense. In *Reflections on the Birth of Venus* (1976) Rosenbach stands within a projection of the Botticelli painting, so that its culturally clichéd images of an outdated ideal of beauty standing in for the female body are inscribed upon her.

The definition of "femininity" became increasingly more varied and complex in the years that followed. Artists began treating this thematic area in an unpretentious way, and "masculine" and "feminine" approaches became strategies that were no longer mutually exclusive. In the 1980s the pop icon Madonna was an exemplary embodiment of the new rising "female matter-of-factness", proposing a playful manner of dealing with increasingly faded role models.

Artists such as Pipilotti Rist, Andrea Frazer, Mona Hatoum, Sam Taylor-Wood, and Vanessa Beecroft now seamlessly combined conceptual, documentary, and performative approaches. Fiction and reality, parody and authenticity, permeated each other and avoided the dogmatic and emancipatory character of the topic's early years.

entering intermedial space

The human body played a central role in the "departure from the picture", and experienced another upward valuation when art re-

Centrum in Antwerp, which becomes Europe's most important institution for video production and distribution
1974 — A series of video presentations named "Projects: Video" opens in the Museum of Modern Art, New York

15

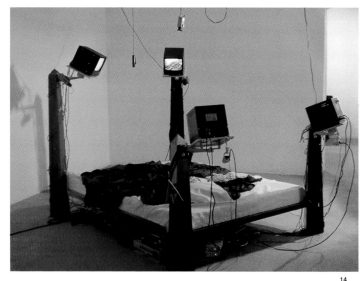

14. JULIA SCHER
The Surveillance Bed III
2000, mixed media, 130 x 240 x 150 cm

15. CHANTEL AKERMAN
From the Other Side
2002, film installation for 18 monitors and 2 screens,
Super-16 and video on DVD, real-time transmission
documenta 11, Kassel (detail)

16. DIANA THATER
Delphine
1999, 4 LCD video projectors; 18 video monitors;
6 laser disc players, 16 laser discs; 1 Laserplay-4
synchronizer, 2 VVR-1000 video processors, Lee Filters
and existing architecture, image size variable
Installation in Kunsthalle Bremen, Bremen

14

entered the third dimension in the 1950s. The traversable pieces of Installation art now demanded recipients who actively entered into the cognitive process, emotionally as well as physically; without such partners the artistic work remained inactive. Video installations took on a special status within such extensive artistic trends, since here spatial and temporal components corresponded with each other on various levels. Walking through a video installation placed viewers in a situation in which they saw their own individuality confronted with an electronic, moving image. Several spheres met here: the private sphere of the recipient, the artistic sphere, and the sphere – associated with film and television – of media. Voyeuristic and exhibitionist experiences were just as likely to occur as feelings of discomfort and mental self-dissolution.

Around 1970 Bruce Nauman and Dan Graham, among others, set new standards with their video-based room installations. Like many of their colleagues they used a live video feedback system, showing images recorded by the camera on a monitor at the same time as they were taken. In Nauman's *Live/Taped Video Corridor* (1970) two monitors stacked on each other were placed at the end of a narrow corridor built of wooden panels. On one screen the artist showed a tape, produced earlier, with a view of an empty room; the other screen showed a live image of the visitor in the corridor. The closer viewers came to the apparatus, however, the smaller they appeared on the monitor. The camera taking the shot was located

across from the playback device, above the entrance to the corridor. It confusingly reflected the viewer's progress through the passage in reverse, and visually multiplied the feeling of physical distress already caused by the confining space. The viewer's sense of orientation and mental security were equally challenged by this video installation.

Beginning in 1974, Dan Graham used live video feedback like a series of experiments. Thereby he was less interested in creating unsettling physical experiences, and instead aimed at producing duplicate images of people that would allow them to experience their own presence. In one or even several rooms, strolling art consumers saw themselves incessantly confronted with their electronic counterparts or after-images. For, although the camera transmitted a live image of the person, a technical slight-of-hand caused it to appear on the monitor after a short delay. Several screens installed in the wall in such a way as to seem to be pictures, as well as further mirrored walls, split viewers into numerous pictorial appearances.

With live video feedback it is also possible, however, to either obviously or surreptitiously monitor and supervise people and areas. Video art has profited not least from state-of-the-art surveillance technology. Artists such as Chantal Akerman, Haroun Farocki, Paul Pfeiffer, Julia Scher, Ann-Sofi Sidén, and Peter Weibel act out strategies of power and control. The self-awareness aimed for here is generally a feeling of being at the mercy of something beyond one's control, and the criticism levelled at television as early as the 1960s as

1975 — Video exhibitions: "Artists' Video Tapes" in the Palais des Beaux-Arts, Brussels; "Video International" in Copenhagen; video section with 28 artists at the 9th Paris Biennale; "Video Show" in the Serpentine Gallery, London; "First International Exhibition of Video"

15 16

being a mass media and status symbol remains true in the era of reality TV and Webcams.

In the 1990s an increasingly open form of presentation for video installation developed. The electronic image then took up a roving existence between monitor and projection. Mona Hatoum, for example, placed a video image on a plate that was part of a table setting, and Tony Oursler created anthropomorphic doll-creatures by combining projected images with diverse materials. Both artists touch upon the realm of sculpture. Aernout Mik, on the other hand, designed architectural structures that formed an inseparable spatial unit with his projection surfaces.

Pipilotti Rist and Diana Thater are two artists who play with mentally annexing the viewer in their video installations. With their monumental projections which, from various perspectives, overlay the real architecture and create their own illusionistic space, they approach the strategies of feature films: that is, conventional narrative films aim at suspending cinema visitors' belief and getting them to identify with the plot. In *Delphine* (1999) Thater transforms the exhibition space into a colourful underwater world, into which visitors are submerged. They can drift in space and with the images, until they run into the video-wall made up of nine monitors. The wall's sculptural presence makes it both a centre of attraction and a disturbance factor. In this function the monitor brings viewers out of their state of image-induced intoxication and back to media reality. Rist proceeds

similarly in the work *Homo sapiens sapiens*, which she created in the church of San Staë for the 2005 Venice Biennial. She overran the vault of the dome with a suggestive river of imagery, which further emphasized the vertical rise of the baroque architecture and the ceiling fresco. Viewers rested on floor mats, and in this relaxing environment they were able to lose themselves in the tapestry of images. Unlike Thater, Rist left it up to the recipients to decide when they wanted to take their leave of the evocative flow of colourful pictures.

Time codes

Video is an explicitly time-based artistic medium. The job of the technical apparatus is to record temporal sequences and produce temporal structures. In traversable video installations such as Pipilotti Rist's 2005 Biennial contribution, recipients themselves already had to define the amount of time they wished to invest in experiencing the art-work. Viewers decided when to enter the flow of pictures, how long their reception time would be, and when to leave. Particularly for long video pieces, confusing multiple projections, or endless loops, the independence this demands can certainly create uncertainty, since complete comprehension of the piece is possible only with difficulty. This strategy is an essential aspect of many video installations created since the early 1990s. In contrast, installative video work from the

in Milan; "Art de Video" in Caracas; "Projected Video" in the Whitney Museum of American Art, New York
1975 — Sony develops Betamax, making it possible to record TV-broadcastings on video tape

17

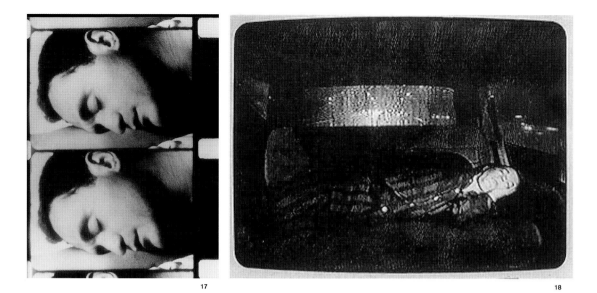

17
18

late 1960s and 1970s is often marked by a passageway-like character, making it easier to conclude the act of cognition, or to repeat it incessantly.

It was also typical of this early phase for artists to record their performances in real time. These works had the air of documentary recordings. The pictorial material was also edited during or after the action by the artists, however, through perspective shots, shot sequence, pictorial rhythm, or montage. The electronic document that brings the past action into the present also provides a commentary, or produces a further aestheticization.

Real time remained a significant factor in the further development of Video art. Thus in *The Bordeaux Piece* (2004), David Claerbout staged a short narrative which repeated itself identically over the course of a day. The first iteration began at sunrise, after which the actors continually repeated it until after night had fallen. Analogously to its recording time, the tape is played from morning until evening in the exhibition room. The projection therefore lasts for 13 hours, and cannot be completely viewed during a museum's normal opening hours.

Claerbout's work, however, also exhibits clear links to conventional narrative cinema, which works with a parallel film time not connected to reality. The ideal aim of this type of different time level is for the cinema audience to synchronize themselves with it, meaning that they should enter fully into the story and its temporal narrative. Since

the end of 1970s and particularly in the 1980s, artists have been seizing upon this strategy of the film industry . They make use of the possibilities of identification, but break with the linear narrative form in different ways.

Bill Viola is one artist who produces timing scores in the broad field between real time and film time à la Hollywood. Already in his early major work *The Reflecting Pool* (1977–1979) Viola collaged various time zones and speeds on his pictorial surface. Only one camera perspective exists – a view of a swimming pool. Yet the banal action of a person leaping into the water disintegrates into different windows of time. In one phase the figure freezes mid-jump above the pool, while waves continue to traverse the surface of the water. The natural sounds from the woodland behind the pool also continue unabated. Using suggestive images and complex temporal forms, Viola moulds forceful metaphors – in this case, the baptism of man, spiritual cleansing, death, and rebirth.

Temporal structures have also developed in Video art, however, which stand in diametrical opposition to the illusionism of conventional film. The loop is one possibility in which generally shorter periods of time can be placed in a series of endless repetitions. Thereby the reception of the work does not have to end after the completion of one sequence. On the contrary, the permanent repetition often only becomes apparent after longer observation. In this way the time segments can always seem identical or, as in *Win, Place or Show* (1998)

1976 — "Video Art: An Overview" in the San Francisco Museum of Modern Art
1977 — The Centre Georges Pompidou in Paris establishes a photo-film-video-department and buys approximately 50 video artworks

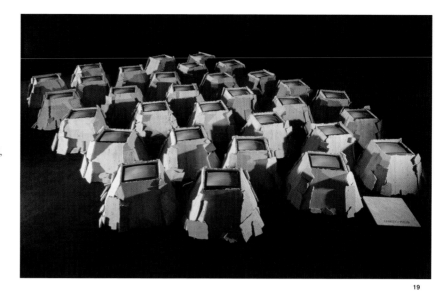

17. ANDY WARHOL
<u>Sleep</u>
1963, black-and-white 16-mm film, without sound,
5 h 21 min

18. RODNEY GRAHAM
<u>Halcion Sleep</u>
1994, video projection, 26 min

19. FABRIZIO PLESSI
<u>Sea of Marble</u>
1986, mixed media
Installation ArtWare, Hanover

19

by Stan Douglas, minimal changes can sneak into every narrative seg-ment creating additional levels of reflection.

The extreme slowing of the speed of images constitutes a fur-ther language of time beyond "normal" and cinematic time concepts. Here too, differentiation can be made between so-called duration pieces and hyper-slow motion. For duration pieces the camera records a barely changing object in a single shot over a longer period of time. Real-time recording is used here, in order to suggest that the images are slowed down. Both Andy Warhol in *Sleep* (1963) and Rodney Graham in *Halcion Sleep* (1994) focused on a sleeping per-son, thereby taking the duration of time as their theme.

In hyper-slow motion, on the other hand, the movement in the images is actually slowed down by technical means. Changes become barely perceptible. On the contrary, the impression arises that it is a still image, a tableau vivant, which is changing negligibly. Bill Viola perfected this temporal structure in *The Greetings* (1995) and, at the 49th Venice Biennial in 2001 with her work *Trying*, the artist Liza May Post transformed the Dutch pavilion into an adventure space by reducing the movement in the videos to an extreme to play photo-graphic and videographic time-structures off against each other.

The 1980s

In the 1980s video advanced to being the sole means of ex-pression for many artists. The general social climate was influenced by a conservative, neo-liberal attitude, which had its incarnation in the politics of the British Prime Minister Margaret Thatcher. The blossom-ing of figurative painting and the increasing influence of the booming art market made this decade's restorative character tangible in the field of art as well. Making names for themselves in this context to-gether with the pioneers were, among others, Klaus vom Bruch, Robert Cahen, Gary Hill, Marie-Jo Lafontaine, Marcel Odenbach, Tony Oursler, Fabrizio Plessi, Bill Seaman, and Bill Viola. Video equipment became increasingly affordable, easier to use, and technically better developed. In this phase many Video artists – a label which had by then become common – used the classical artistic discipline of sculp-ture to expand Video art.

Nam June Paik had already set standards in this area with his *TV-Cross* (1966), *TV-Buddha* (1974), and *TV-Garden* (1977), and Les Levine created one of the first video wall pieces with his 1968 work entitled *Iris*. In the 1980s new semantic forms were created by the placement of monitors in series – as a wall, a staggered series, or dispersed – or they were presented in such a way that the configura-tion of the equipment corresponded to the content of the tape. With *Crux (It's Time to Turn the Record Over)* (1983–1987), Gary Hill

1979 — The first Ars Electronica Festival in Linz
consumer Camcorder

1980 — Sony presents the first
1981 — "Performance, Video, Installation", in the Tate Gallery, London

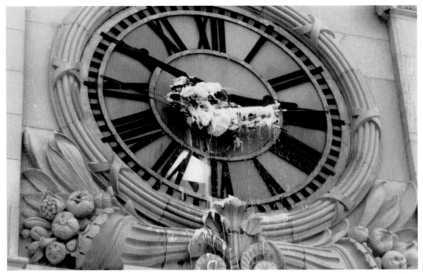

20

20. GORDON MATTA-CLARK

<u>Clockshower</u>
1973, 16-mm film, 13 min 50 sec

21. SAM TAYLOR-WOOD

<u>Atlantic</u>
1997, 3 laser discs for 3 projections,
10 min 25 sec

presented a work that originated in a performance, with five monitors depicting the ends of a Latin cross, whereby the screens showed the head, hands, and feet (on two monitors) of a crucified man.

The flow of electronic images no longer merely reproduced the bare surface of reality in a documentary manner, as had been usual in the early 1970s. Supported by computer programmers, the camera was now much more of an instrument for visualizing complex narratives and fictions. Thereby artists often view things from a holistic perspective, to which they give expression through the use of symbolic and metaphorical images. The media network that was rapidly increasing internationally also demanded an increasingly global perception. "World", said Klaus vom Bruch, "is everything that is the case on television." Criticism of the media giant television therefore continued to be topical, as could be seen also in the works of Antoni Muntadas and Dieter Kiessling. It was in this decade that, on television, the music station MTV established itself, with its short music clips offering a new mixture of art, commerce, and television. Video art broadly reflected this so-called clip aesthetic, which brought with it visual patterns and quick successions of images to overrun the narrative moment of video.

Numerous festivals – Locarno being the first, in 1980 – along with magazines, studios, scholarships, and exhibitions, including documenta 8 (1987), ensured the wide distribution of Video art in the 1980s, and granted the electronic medium an independent arena of presentation.

movie video

Film and video have always had a relationship of productive exchange. Film, the "first born" of the two, set standards in the field of moving pictures, and film pioneers such as Georges Méliès, David Wark Griffith, and Sergej Eisenstein provided fundamental stimulus to the development of film and Video art even at the beginning of the 20th century with new cutting techniques, montage methods, dramatic changes in perspective, and "crosscutting" – in which several narrative levels are intertwined. The directness and "democratic" impetus of video also made the younger medium interesting to the commercial film industry and to independent film.

More recently, in the mid-1990s, several Danish directors including Lars von Trier wrote a manifesto entitled "Dogma" promoting hand-made, uncut films, which thereby reflected significant features of classic video. "Das Fest" (1998) by Thomas Vinterberg was the first film created in accordance with the rigid "Dogma" stipulations.

The first integration of cinematic and videographic elements came about when the French writer-director Jean-Luc Godard experimented with video for a short time beginning in 1968 (*6 fois 2, France tour détour deux enfants*).

In the 1960s, moreover, Expanded Cinema widened the strategy of inter-media incursions. Peter Weibel, VALIE EXPORT, Birgit Hein, and George Landow, among others, have deconstructed formal

1984 — "1. Videonale" in Bonn 1984 — "Video Art, A History" in the Museum of Modern Art, New York
1987 — Jean-Luc Godard starts the video series "Histoire(s) du cinéma", of which the first two parts are shown at the Cannes Film Festival

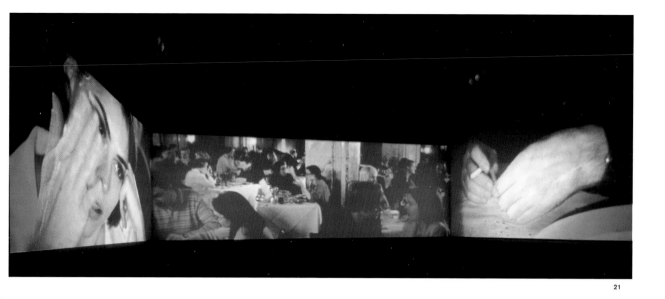

and compositional elements of the cinematographic code. They have used performances, multimedia actions, multiple projections, and the dissection of all of cinema's realities, to reflect upon the structure of film. In 1965 Takehisa Kosugi used a projector without a roll of film to irradiate a paper screen, which he then cut to pieces to the point of its complete eradication. Besides these subversive tendencies, however, artists have also dealt structurally with the cinematic vocabulary. Richard Serra was concerned with Soviet film of the 1920s, and Gordon Matta-Clark, in his filmed performance *Clockshower* (1974), quoted the classic "Safety Last" (1923) with Harold Lloyd. For this Matta-Clark hung from the clock of a skyscraper in New York where, at a dizzying height, he brushed his teeth, shaved, and washed. In the last shot the camera disengaged itself from the close-up of the clock, zoomed out to show the streetscape far below, and only at this point does one become aware of the action's unbelievable dimensions.

In the 1990s the mechanistic and distributive structure of film provided important points of reference to Video art. Artists such as Eija-Liisa Ahtila, Doug Aitken, Janet Cardiff, Stan Douglas, Douglas Gordon, Rodney Graham, Steve McQueen, and Sam Taylor-Wood, among others, used or debated cinematographic parameters. They used cinematic history as a pool of material, produced classics as remakes, or took film itself as a theme: from the film projector to the theatre room, and even the distribution system, the entire environment

of film was up for discussion. Even in the production of their works, many artists negated classical production formats. They filmed on 35 mm, stored the work digitally on DVD, edited images on the computer, or worked in a direction exactly opposite to this. The hybrid character that video assumed in the 1990s questioned definitions and genres with regard to film and video.

Feature films, however, are associated with particular images and codes in the so-called collective cultural memory: the films are customarily shown in darkened theatres on a large screen. In this type of space the persuasive Hollywood aesthetics bring consumers under their spell through perfect illusionism. Viewers temporarily exchange their own bodies and their own identities for a manipulated, projected reality. In 1998 the film industry exemplarily presented these mechanisms in a sharp satire of itself in the feature film "The Truman Show".

Art breaks with the conventional perspective of film in various ways. Video installations use multiple projections, split screens (an image divided into several fields), or screens placed away from walls to allow them to be viewed from front and back simultaneously, to hinder any identification with the camera-eye characteristic of film. Film history and its classics, heroes, and icons, provide a rich reservoir of image material for artists to isolate, defamiliarize, and place in new contexts. Thus in *10ms −1* (1994) Douglas Gordon stretches found footage, a piece of medical documentary from the early days of film, to an extremely long playing time.

1989 — "ARTEC '89", the first biennale for art and technology, takes place in the Nagoya City Art and Science Museum 1990 — Kunsthochschule für Medien (Art College for Media) opens in Cologne 1990 — "Passages de l'image" in the Centre Georges Pompidou, Paris

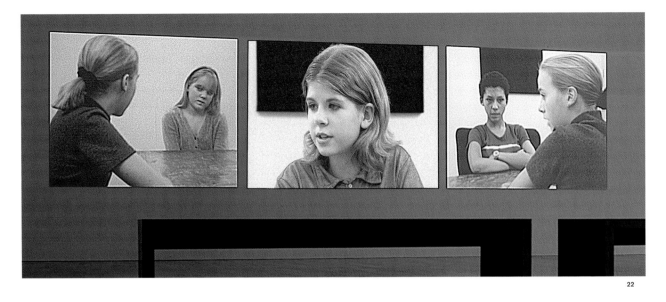

While media culture is made tangible in this type of work by ex-tracting it from its original context and conceptually reprocessing it, entire narrative threads can be contextually shifted in remakes.

The Third Memory (2000) by Pierre Huyghe resembles a palimpsest in which a story has been overlaid by several layers of me-dia. Its point of origin was a real bank raid that television had broad-cast live. The robber was arrested and the story marketed as the fea-ture film "Dog Day Afternoon" (1975), directed by Sidney Lumet and with Al Pacino in the leading role. Huyghe recreated the event once again, whereby the original bank robber now played himself. Huyghe mixed his new material taken from the replayed action with the media images already available. Documentary, cinematically produced, and subjectively remembered elements intertwine in this re-placement, and one can see how reality, media image, and reminiscence mutually influence each other.

In the installation *Playhouse* (1997), Janet Cardiff and George Bures Miller combine the world of the theatre with the electronic pos-sibilities of video. Viewers enter a small room set up like a theatre. One's gaze is directed to a stage upon which a (projected) opera singer performs. Noises, scraps of conversation, and a dialogue are played over headphones, and these overlay the atmosphere of the theatre with completely different, mysterious events: "There's a suit-case under your seat. It has everything you'll need … It's up to you now." Through this flow of acoustic information, the content of which remains a mystery, Cardiff and Miller break with the illusionism of mu-sical presentations and the world of theatre.

Theatre – or rather the theatrical – has provided another point of reference for Video art over the last ten years. It has introduced a form of affective artificiality into works constructed to be cinematical-ly illusionist, as well as those in a documentary style. Thus in *High Anxieties* (1998) Monika Oechsler filmed five girls reading a fabricat-ed dialogue, in which she gave them the words of grown-ups to speak. The artificiality of the scripted situation becomes obvious only slowly and, in addition to the link with theatre, also references staged television formats such as mockumentaries or courtroom dramas.

Works produced on painstakingly built sets seem no less the-atrical. With *Der Sandmann* (1995) Stan Douglas plays upon the sto-ry of the same name by E. T. A. Hoffmann from the year 1817, which had already inspired Georges Méliès to create a cinematic interpreta-tion of it around 1900. Douglas located his sandman story in two al-lotment gardens in Potsdam, which he had painstakingly and authen-tically rebuilt in the studio. The camera travels 360° around the set while quotations are read from the letters of Nathanael and Clara, the protagonists in Hoffmann's story. In the course of the narrative, the set does not dissolve as is common in entertainment cinema, but instead remains as a structural element of the piece.

1996 — A 23-year-old American student launches the web site "JenniCAM", on which she invariably displays, until 2003, real-time video – 24 hours – of her daily activities
1997 — Sony launches the first digital Camcorder in the USA

2. MONIKA OECHSLER

High Anxieties
1998, 3-channel video projection,
each 3 min 50 sec

3. JANET CARDIFF AND
GEORGE BURES MILLER

The Paradise Institute
2001, wood, theatre seats, video projection,
headphones and mixed media,
99.7 x 1772.9 x 533.4 cm

"Our life is half natural and half techno-
logical. Half-and-half is good. You
cannot deny that high-tech is progress.
We need it for jobs. Yet if you make only
high-tech, you make war. So we must
have a strong human element to
keep modesty and natural life."

Nam June Paik

23

The 1990s

Since its beginnings, video has stood in relation to other artistic languages and media such as television, performance, sculpture, and film. The development of digital technology also made it a functional hybrid in the 1990s. Regardless of their original storage format, many things such as images from the global flow of data, "hand-made" recordings, and historical material have been integrated into the intermedia artistic practice. Thereby the most varied of formats in a digital state could be synthesised unproblematically, and familiar image aesthetics such as the flicker of a 35-mm film reel or the blurry focus of earlier magnetic tapes could be simulated. Besides their technical equipment, the artists who worked with electronic media employed such a variety of materials that any labelling of the work or of the artist seems superfluous. Therefore, since the beginning of the 1990s, the "video artist" has already ceased to exist. Today more than ever video in the artistic context means the appearance of moving, electronic images.

Despite the multifaceted character of video, some strategies and topics stand out in the everyday artistic life of the 1990s. Linear narrative, which artists had already begun reworking in the 1980s, developed into an extremely complex structure. Thereby clear emphasis has been placed on the dual composition of narrative videos: they tell a story in cinematically perfect quality, and simultaneously demonstrate their videographic syntax. Film history, with its special aesthetics and iconic vocabulary, generally provides a rich source of images. Artistic utilization of audio-visual film material that is already available, so-called found footage, also always attests to a critical treatment both of cultural codes and of habits of perception long since conditioned by mass media. Viewers must bring a high level of media competence to the reception, in order to be able to follow the replays of, and references to, media images.

As a result media culture itself, as was already the case in the 1960s, remains an important emphasis of Video art. However, the often fundamental criticism in the 1970s of the power structures of film and television has transformed into cynical and occasionally ironic commentary. Other strategies of earlier video history have also been reconsidered by a younger generation of artists. The performative approach has produced actions based on directorial instructions, which are often placed in settings which otherwise would only be used in the film and television industry. In the world of global players, data highways, enormous increases in population, and drastic migration movements, one must again define the position of one's own identity. Thereby artists use subjective camera work to examine private perspectives and disassociate themselves from other individuals. The human body remains an important point of reference in this context.

For some time now the Western world has no longer been the sole centre of economics and culture in all of this, but rather part of a

1997 — Zentrum für Kunst und Medientechnologie (ZKM) opens in Karlsruhe

1999 — "Fast Forward: New Chinese Video Art" in Centro de Arte Contemporânea de Macau

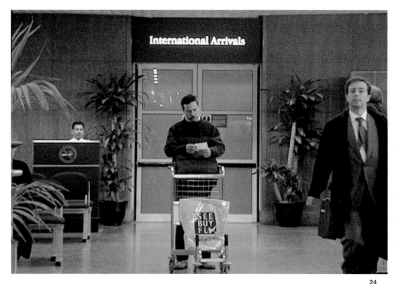

24. MARK WALLINGER
<u>Threshold to Kingdom</u>
2000, projected video installation,
11 min 10 sec

25. JANE & LOUISE WILSON
<u>Dream Time</u>
2001, 35-mm film, 7 min 11 sec

26. KUTLUG ATAMAN
<u>The Four Seasons of Veronica Read</u>
2002, 4 DVDs, each approx. 1 hour

24

global network. Documentary itemization, self-questioning, and cultural sampling are videographic practices with which artists react to these changed realities.

Video has become a naturally accepted part of the art world, as the last major exhibitions in Venice, Kassel, and other art centres have shown. Few exhibitions can now do without moving pictures, yet the gulf between festival situations and the White Cubes of the museums has not yet been closed. Thereby over the last ten years video has managed to gain for itself the status of the original. Artists produce their image installations in limited editions or as a unique piece, thereby creating an artificial exclusivity that increases both the perceived value and the financial value of the video work. Today, video has become a contradiction, either an exclusive or a mass-produced commodity, as opposed to the 1970s when the VHS-cassette shared status with graphical prints and was valued correspondingly. Through the use of DVDs that include exhibition catalogues, or can be affordably acquired, however, some artists are also aligning themselves with the medium of video's more "democratic" aura.

ın-between: ɒocumentary format and world views

Since the 1980s narrative structures have formed a constant in media works. Guiding principles with which the flexible medium of video could continue working have been provided by classical feature films, but also by literary highlights such as James Joyce's "Finnegan's Wake" (1939). Image, sound that is often blended as a voiceover with the images, and text are no longer laid out as a unit, but instead create complex relationships on various narrative levels, as presented in ideal form by Eija-Liisa Ahtila in her multi-screen video installation *Talo/The House* (2002).

This construction of reality has, for some time, been working against the approach that represents reality, and it is championed by artists such as Kutlug Ataman, Annika Eriksson, Fiona Tan, Gitte Villesen, Mark Wallinger, and Jane & Louise Wilson. It is characterized by a documentary style that remains close to reality, but is nonetheless mixed with videographic means of expression. In an interview, the artist Gitte Villesen gave this general summary of the status of documentary video: "I want the line between art and documentary, fiction and reality, to be burred."

The documentary format is based on a tradition that has been moulded by experimental film, by socio-historical film studies, and by writer-directors such as Chantal Akerman, Chris Marker, and Jean Rouch. In the documentary style artists remain close to real-time events. They comment upon an isolated piece of reality by using known technical interventions such as the manipulation of temporal structure, splicing, and shot composition, as well as the employment of sound, speech, and text. They append these modifications to the

2000 — "Three Decades of Video Art" is presented by VideoCulture in Detroit **2002 — The Endoscope Camera,**
an 11 x 30 mm capsule able to be swallowed, is invented, which transmits images from inside the body

24

25 26

documentary aspects of the piece, without destroying the overall feeling of authenticity. If artists do not use pre-existing audiovisual material for their work, then it is mandatory for them to be very closely or even directly involved in a situation. They are working with their cameras in a zone between passive presence and active intervention. The presence of a filming camera also creates a situation of exceptional circumstances for the participants, who suddenly see themselves and their "normal" everyday life exposed.

For *Threshold to the Kingdom* (2000) Mark Wallinger filmed the "International Arrivals" doorway at an airport. At irregular intervals, individuals or groups of people appear through the door from out of the "heavenly emptiness". Through the concentrated perspective and the slowing down of reality, a familiar scene gains a symbolic meta-level upon which the cycle of life is debated. In *Uomoduomo* (2000) Anri Sala also worked with a fixed camera position. He portrayed an old man sleeping on a church pew, his personality defined not through an exchange of glances, but rather by the small movements of someone sleeping in a sitting posture. Events, as image and sound, continue around him in normal time, while the sleeper belongs to a completely different temporal state.

In contrast, in their video installation *Dream Time* (2001), Jane & Louise Wilson unveil a real myth by attending a rocket launch in the long-inaccessible centre of Baikonur (formerly in the Soviet Union, today Kazakhstan). They presented the tape as a single-screen installation both in real time and in slow motion, reintroducing the mystery of the location and events through the media technique of intentionally blurring the images. In *The Four Seasons of Veronica Read* (2002) Kutlug Ataman produced a video documentation of the four seasons of the hippeastrum, a type of amaryllis, and its dedicated grower. Veronica Read had completely dedicated her residential flat to growing hippeastrums. In his video Ataman analysed both the plant's organism, as well as the hobby biologist's social behaviour.

With their "video documentations", these artists and others provide sketchily outlined, individual impressions of the world. They reconcile near and far, and make the strange and the personal into central categories of their work. A young generation of artists unravels a world community grown much closer through globalization and media networking, and in the gap between universal and particular, Media art and society, finds a piece of reality.

2002 — Approximately two thirds of all middle and high schools in the USA are equipped with video surveillance systems

Balkan Baroque

Solo performance, Venice Biennal, 4 days and 6 hours (bones, copper buckets, copper tub, water, 3-channel video)

*** 1946 in Belgrade (formerly Yugoslavia, today Serbia)**

In the performance *Balkan Baroque*, Marina Abramovic sits on a mountain of 1,500 fresh beef bones. Three large projections are shown on the walls depicting her mother, her father, and the artist herself. Two copper buckets and a copper tub filled with water are also in the room. Over a period of four days, for six hours each day, Abramovic washes the bones while continuously singing folk songs from her native country. She was born in Yugoslavia, which ceased to exist as a nation-state in 2003. Since 1991 the Yugoslavian autonomous republics – Kosovo and Croatia, among others – have gained their independence in an inhuman fratricidal war with "ethnic cleansing".

As early as the 1970s Abramovic began provoking audiences with her extreme performances in which she transcends her physical limits again and again. She confronts the audience with the presence of her naked body, maltreats her body with knife wounds, or sets up situations in which viewers are exposed to the artist's static presence for many hours. In the performance *Thomas Lips* (1975), after inflicting a series of injuries on herself the artist ended up lying naked on a block of ice until the audience freed her from this life-threatening situation. For many years Abramovic carried out actions with her life-companion Ulay, thus also making the relationship between man and woman a topic of her work. Today this active performer passes her experiences on to younger artists within the context of the Independent Performance Group that she founded in Berlin in 2003.

When Abramovic presented the *Balkan Baroque* performance at the Venice Biennial in 1997 she delivered an impressive work that promotes coming to terms with national and biographical history. While helplessness and anger about the events taking place in former Yugoslavia still remained at the emotional centre of the theatre performance *Delusional* (1994), three years later the artist demonstrated her mourning for a state of affairs that could no longer be changed.

The still bloody bones brought to mind the innumerable victims of the war. The ritual ablution of every single bone began the process of emotionally overcoming the loss.

Abramovic accompanied the energy-draining act of cleansing with folk songs – a song from one of the republics for each day – which she incessantly repeated. As frequently in her actions, the artist drew upon age-old traditions, in this case using the songs of grief to cope with death and the separation of mourners in her former native country. Abramovic uses the three video images to shift the metaphorical and body-related level of her action into the realm of biographical reminiscence. The busts of her father and mother refer to the eventful personal histories of her parents who, since the 1940s, had taken an active part in the country's political upheavals. The full figure of the artist appears on the third screen. In one scene she appears as a white-coated zoologist who tells the story of the Balkan wolf rats – a special species of rat that destroys itself; in another scene she dances ecstatically to the music of folk songs.

For Abramovic, public appearance is an indispensable part of her actions. "If I cut my finger while peeling potatoes in the kitchen", she says, "I feel very vulnerable and could cry. If I injure myself in front of an audience this doesn't bother me in the least. I can do practically anything. There are no more obstacles. I have a feeling of absolute freedom."

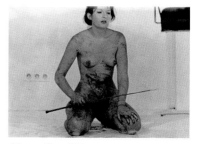

Thomas Lips, 1975

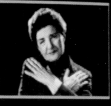

3 Adaptation studies (1. Blindfolded catching)

Super-8 film, black-and-white, without sound, 3 min each

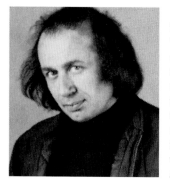

* 1940 in New York (NY), USA

With his conceptual works focusing on the human body, Vito Acconci was one of the major protagonists of Action art around 1970. His complete works, however, go far beyond this performative approach. From the beginning his artistic work was marked by a dialogue between interior and exterior, private and public, and this led Acconci from performance and installation to works within the context of public art and architecture. Acconci originally studied English literature and composed texts, and in New York in 1967 he published the literary magazine "0 to 9" together with Bernadette Mayer. In the contexts of Conceptual and Minimal art he broadened the act of writing into an expansive, physical action, in which the complex system "literature" – page, text, reading, body, and place – was open for negotiation.

Beginning in 1969 Acconci focused on his body as material, producing over the next three years a large number of conceptual performances in public spaces, galleries, and his studio, sometimes with an audience, sometimes without. Thus the lens, whether that of a film or a video camera, served as a narcissistic mirror and a medium for reflection. It represented an interface between private and public domains, and real body and media body image, as well as between presence and absence. "Face-to-face contact: person onscreen faces person in front of screen. (The video-viewer is met by a screen approximately face-size – whereas, in film, the viewer encounters a screen 20 feet high.)" For Acconci the camera's presence is an essential part of the action. The direct gaze into the lens and the "camera eye" looking back demarcate a circuit in which the artist monitors himself, the dimensions of which he simultaneously guides towards openness: the body is dematerialised, past actions become the media's present, and that which is private is pushed into the public domain.

Acconci organized his performances according to a defined plan, and the processes are not infrequently like experimental set-ups in which he analyses the composition of the human body, its physical limits, and its emotional capacity for expression.

In *3 Adaptation Studies*, filmed on Super-8, the artist's body adapts itself to three different and unusual situations. In *Blindfolded Catching* Acconci, whose eyes are bound, allows someone to throw a rubber ball directly at him, forcing his body to react to attacks that are to him invisible; in *Hand and Mouth* he repeatedly sticks his own hand as deeply as possible into his mouth; in *Soap and Eyes* he gazes directly into the camera – as he so often does – and squirts soapy water into his eyes, until it is hardly possible for him to keep them open anymore.

In this trilogy Acconci builds tension for the viewer of the monitor. Although one initially watches the body's defensive reactions with relative disinterest, watching the hand being stuffed in the mouth provokes a feeling of downright physical discomfort. In the final sequence Acconci suddenly breaks eye contact with the camera, thereby distancing himself from his audience in front of the monitor. Viewers lose the sense of immediacy and gain a feeling for the distance that exists between the past event and its pictorial reproduction.

Acconci sees the media image as a calculable factor and intentionally employs it as an instrument of power. The negative corollary effects of the media image finally affected Acconci himself, as his face, body, and actions became a trademark due to their permanent media presence. In 1973 this form of iconisation as well as interference in the actions by audience members made it necessary for Acconci to physically withdraw from his own works.

Following Piece, 1969

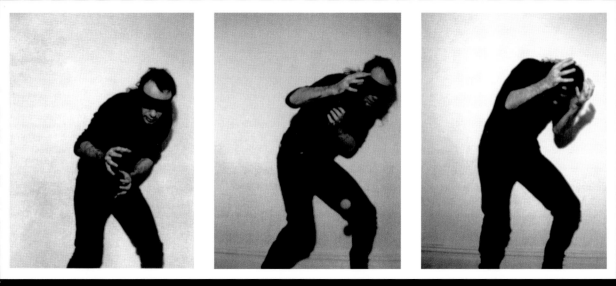

тalo/тhе ноusе

3-channel video, DVD, colour, sound, 14 min

* 1959 in Hämeenlinna, Finland

Eija-Liisa Ahtila belongs to a younger generation of artists who experiment with diverse narrative structures. She breaks with patterns of linear narrative, and formulates discontinuous stories which, with their intricate and multifaceted perspectives, are structurally reminiscent of the novels of James Joyce. Thereby Ahtila invalidates hand-me-down, static ideas of time and space, and rethinks the fundamental conditions of existence in the context of real situations. The starting point for her complexly contrived structures are usually social networks, such as those arising through partnerships, for example (*Consolation Service*, 1999).

Ahtila is also interested in people who find themselves in a phase of radical change in their lives, like the five girls aged 13 to 15 in *If 6 Was 9* (1995) who experience their blossoming sexuality in different ways, and describe it in front of the camera.

For her work Ahtila uses the media of film and video, which she then presents in various locations, not only in cinemas but also in the white cubes of museum exhibitions. Based on primary research and documentation she develops a plot, which is interpreted by actors in scenes that are, to some extent, socially authentic. Thereby allusions to related types of media such as advertisements or music videos always materialize in the cinematic scenes.

The video installation *Talo/The House*, which was first seen at documenta 11 in Kassel, is laid out as a three-part projection. Ahtila tells the story of a woman whose connection to reality begins to dissolve. The woman hears voices that disrupt her everyday life and invalidate the "normal" structure of space and time. This work was based upon discussions with psychosis patients who had overcome their illness. Ahtila attempts to cinematically understand an altered spatial and temporal perception, and to audio-visually reproduce abnormal thought processes.

The protagonist is Elisa, whose house and garden, as well as a spruce wood nearby, delimit the terrain of the transformation. When Elisa comes home by car and enters the house, the off-camera voice begins: "I have a house. There are rooms in the house." The voice is heard as a voiceover in Finnish; the text appears in the picture in English translation. The three screens show different motifs and viewpoints that continually alternate: perspectively distorted details from the house's interior alternate with views of the surrounding woods and the building's exterior. The sequence of the shots seems randomly chosen and aimless. The suspension of reality is revealed through single incidents: the hum of the refrigerator can be heard in the living room, but not in the kitchen; a cow seen on the television follows Elisa through the room.

The loss of reality is intensified by fantastic moments as experienced in surreal painting; eventually Elisa herself floats freely in a piece of woodland. The voice from off-camera tells us that no place is certain anymore. Finally not only do space and time change, but the protagonist's physical appearance also goes through a metamorphosis. The eyes, initially portrayed in numerous close-ups as windows to the soul, are now of different sizes, the cheeks are displaced, and the upper lip becomes somewhat thicker. Like the house, the human shell also seems to dissipate with time.

In her work Ahtila constantly negotiates identities in a state of openness and thereby often uncertainty; this is also the case in *Talo/The House*.

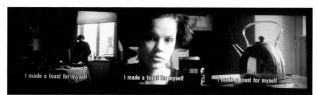

If 6 Was 9, 1995

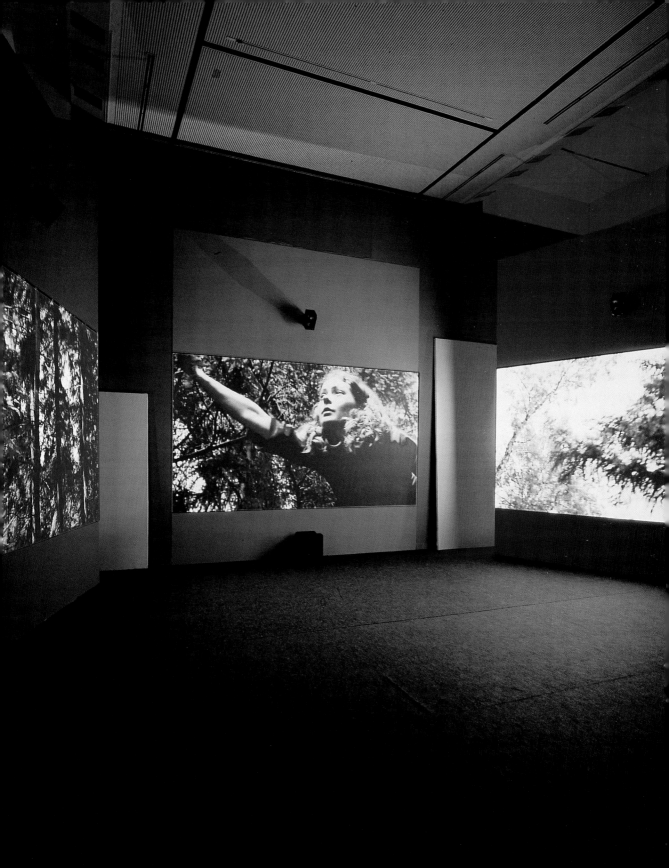

Electric Earth

8-channel video, film on laserdisc, colour, sound, 9 min 50 sec

* 1968 in Redondo Beach (CA), USA

Doug Aitken achieved his artistic breakthrough with *Electric Earth* in 1999 at the 48th Venice Biennial, receiving the Biennial's International Prize. He combines film, video, architecture, sound, and photography into impressive choreographies in his installations, in which acoustic, visual, and spatial elements are intertwined. Thereby he focuses again and again on people and their relationship to their social and natural environments. Desolate landscapes, deserted towns, dilapidated industrial zones, and the repercussions of a global media culture are the central locations and subjects that concern the artist.

In the first scene of the barely 10-minute long video *Electric Earth*, a young man lies on a bed and uses the remote control to zap through the television channels. He murmurs: "A lot of times I dance so fast that I become what's around me. It's like food for me. I, like, absorb that energy, absorb the information. It's like I eat it. That's the only now I get."

In the following scene the protagonist is seen walking through the deserted city at night. He crosses the airport, walks through streets, passes by businesses, and traverses a parking lot, continually repeating the last sentence spoken: "That's the only now I get." The principal actor's walk takes on a mechanical and increasing rhythm that finds its counterpoint in the big city's electronic features: streetlamps, cash dispensers, shop-window lighting, and the neon lights of laundromats.

The sounds of car windows going up and down, and of a pop machine, combine with the night-time lights to produce an audiovisual sound that defines the city and also incorporates man: "That's the only now I get." The boundary between organic bodies and the mechanical carcasses of vending machines, and between human nature and artificially created elements, becomes permeable; and the old legend of a mechanical entity returns in a contemporary form.

Aitken laid out *Electric Earth* as a multi-screen installation, thus demanding spatial position decisions from the viewers themselves. Various sequences of quickly alternating images are strung together on the individual screens. The camera focuses on details like bank machines, while in another scene reveals the vastness of a parking lot. Focused and unfocused shots alternate on screen, whereby emphasis is placed on the dynamics and volatility of electricity as evinced by the metropolis.

Using the sequencing of cuts, pictorial aesthetics, and the multiple projection screens, the artist transforms the walk through the city, following the sequence of TV-channel zapping, into a pattern: a pattern in a discontinuous structure, which itself carries the rhythm of the story. Therefore for Aitken a linear narrative and a uniform "tapestry of images" are not mutually exclusive information systems. Nevertheless, through the endless stream of electricity, the video installation establishes a dimension that seems boundless. Aitken has visualized the endlessly pulsating (urban) flow of energy at the conclusion of the 20th century.

Monsoon, 1995

Homeward:Bound

2-channel video, film on DVD, 9 min 30 sec

* 1963 in Odo-Eku, Nigeria

Even Oladélé Ajiboyé Bamgboyé's biography provokes questions about one's own cultural identity and the definition of cultural spaces. Born in Nigeria, he has now lived in Great Britain for quite some time. Bamgboyé initially studied chemical and process engineering in Glasgow, later turning to fine art and completing his studies at the Slade College of Fine Art and the University College in London with an MA in Media Fine Art and Theory. He has been popular with an international audience for his photo and video work for some time now.

In a series of photographs from the late 1980s, Bamgboyé defines himself through his body. He poses naked before the camera and uses African textiles in the backgrounds of the scenes. The photo works, strongly aestheticised in this manner, force beholders to examine their views of people of African origins. Where do they come from, under what circumstances do they live, what is their cultural self-image, and which clichés have established themselves?

In the video installation *Homeward:Bound*, first seen at the 1997 documenta X in Kassel, Bamgboyé aims to revise the mass-media and image-clichéd perception of the African continent. Today the western perspective still oscillates between the extremes of romantic glorification resulting from colonialism, and the paralyzing shock triggered worldwide by images in daily news programmes of rebellions, undernourished and maltreated people, and natural catastrophes. As Bamgboyé himself says, he contrasts a picture of normality with these extreme and oversimplified positions.

For *Homeward:Bound* Bamgboyé returned to his native country of Nigeria. In eight chapters in which he restricts his aesthetic interventions either to fades, separating the image from the sound-track, or inserting still images, Bamgboyé documents the "ordinary" and yet simultaneously unusual life in Africa. He focuses upon the topic of water, essential for the continent, by showing youths hauling water or a water-hole in the jungle. In a short sequence in this chapter the artist himself appears as a shadow, camera in hand.

Long camera pans carry us through the country into the city, where bustling activity and turbulent life dominate. The pictures overlap, are restless and blurred, and favour atmospheric moments as opposed to narrative precision of detail. Furthermore, rituals and traditional customs are shown, carried out with musical accompaniment.

In contrast to these atmospheric documentary images, Bamgboyé then supplies a portrait of an individual: Reuben Ayo Ibitoye talks about his life. The camera shows him in front of his house. He talks about his parents, his wish to become a pilot, and his time in the military in West Germany's Uetersen airbase. Old black-and-white photos and newspaper articles support his story. In a second portrait we meet E.D. Bamgboyé. However, he does not so much outline his own situation as that of black Africans in their own country.

In his work *Homeward:Bound*, in which the images imperceptibly oscillate between documentation and an atmospheric mood, it is not only normality in Nigerian life that Bamgboyé has recorded. To a greater extent he has traced the historicity of this African country, unconstrained by clichéd western imagery, within both individual and collective everyday life.

> **"I am concerned with: questions of sexuality with respect to an art practice informed by psychoanalysis; questions of cultural/personal identity; investigating and coming to terms with YORUBA (NIGERIAN) aesthetics within the BLACK DIASPORA (the dispersed cultures of black peoples)."**
>
> Oladélé Ajiboyé Bamgboyé

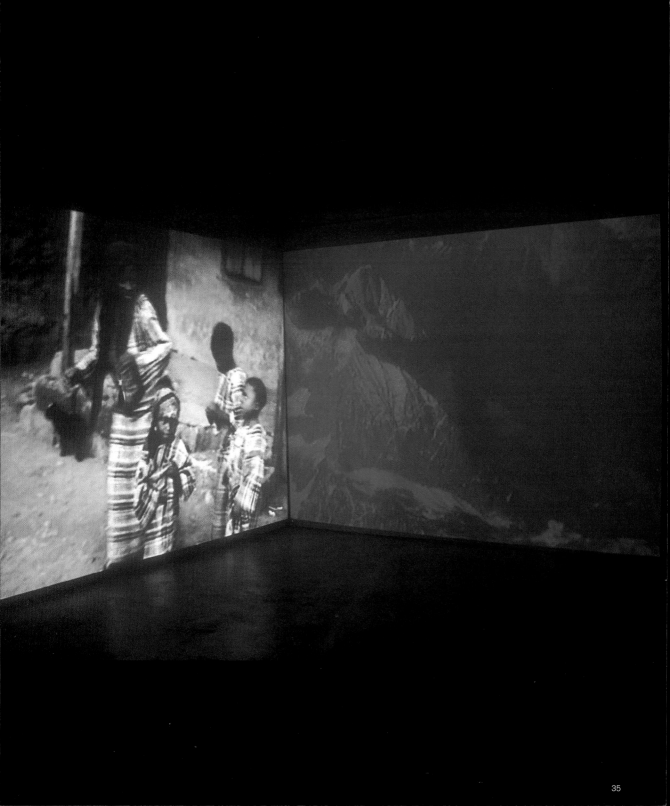

mother + Father

Two 6-channel video installations, colour, sound, *Mother*: 13 min 15 sec, *Father*: 11 min

*** 1972 in Johannesburg, South Africa**

An abundance of emotion assails viewers when they enter the theatrical sphere of the twelve Hollywood stars used by Candice Breitz as a cast in her video installations *Mother* and *Father*. Breitz, who made a brilliant appearance at the Venice Biennial in 2005 with this two-part installation, plays with global codes and canonised images that are an integral part of the collective memory. Raised with a multilayered mix of languages, the South African born artist has created an audio-visual lingua franca, and uses it to highlight the international community conditioned by mass communication.

Six monitors are lined up in rough arcs for both *Mother* and *Father*, and viewers must attempt to associate the monitors in each row with each other as if they were a movie screen. At irregular intervals and in various shots, the faces and figures of Diane Keaton, Meryl Streep, Shirley MacLaine, Faye Dunaway, Julia Roberts, and Susan Sarandon appear on one row of screens, and those of Dustin Hoffman, Steve Martin, Harvey Keitel, Donald Sutherland, Tony Danza, and Jon Voight on the other. They form an impressive phalanx. Breitz has liberated all the protagonists from their cinematic contexts. The narratives, revolving around the complex relationships between mother, father, and children, are blanked out. The Hollywood film becomes iconic raw material. The actors now appear in front of a neutral, dark backdrop. Only a few props, such as the suggestion of stairs, doors, or an armchair, are occasionally able to be seen, and only in a short phase of the barely more than 10-minute videos do children also appear in the picture.

In a painstaking cutting process, Breitz has subjected her protagonists to a visual and acoustic choreography: she abruptly connects various scenes, actions, and short monologues one after the other. The cuts are very sudden. From time to time a screen remains black, while different scenarios are acted out on the others. Individual sequences recur in sound and image in very quick succession – a method reminiscent of a DJ scratching a record, and a means by which, in this work, Breitz shows her fondness for music. The artist sees pop music, in particular, as an essential parameter of our globalised world. In works such as *King* (2005) and *Queen* (2005), which she created contemporaneously, she explicitly focused on the pop scene and its boundless dissemination.

In *Mother* and *Father*, Breitz has produced a rhythmic, electronic collage, in which she interprets the emotional field of tension between mother and child, and father and child, in a manner that is startlingly clear. The actors' theatrical performances, and the repetitions and abrupt changes of camera angle, highlight the isolation of the mother and father figures. Breitz breaks with the cinematic illusionism of the mass medium of cinema, and introduces a theatrical element that emphasizes the pure media presence of the stars. She thereby makes it possible to look critically at the use of images. The exaggerated mother or father image is presented as the product of a dominant media industry.

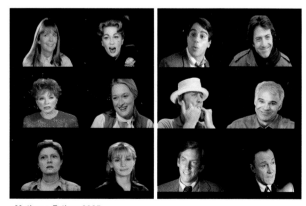

Mother + Father, 2005

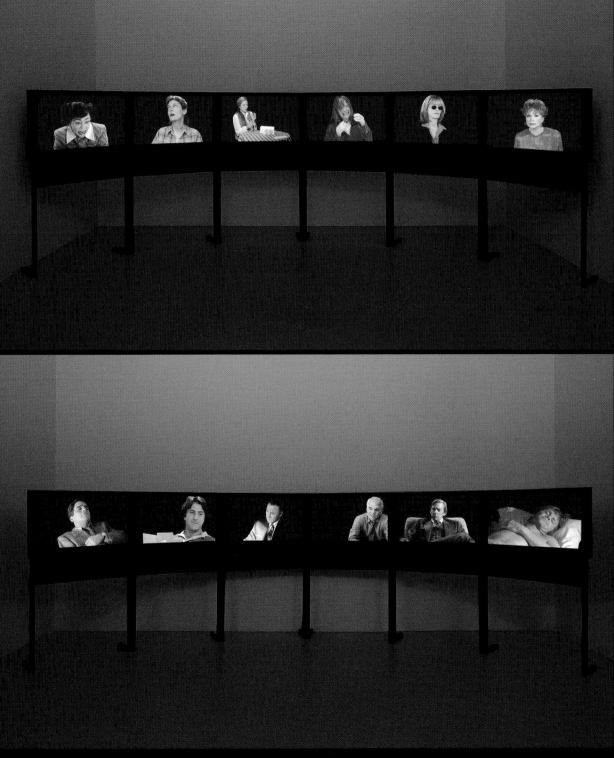

sept visions fugitives

Single-channel video, colour, sound, 30 min

*** 1945 in Valence, France**

In his films and video works – many of which have been made in cooperation with the studio of French national television (Institut National Audio-visuel) – Robert Cahen combines tonal and visual structures, thereby continuing the long tradition of the synthesis of music and visual art. He originally studied concrete music with Pierre Schaeffer at the Conservatoire National Supérieure de Musique de Paris. He builds upon the new systems of scoring music of the 1950s and 1960s, with which composers such as John Cage, Pierre Boulez, and Karlheinz Stockhausen set new standards.

Cahen, however, does not follow the typical path of classical modernism verging towards abstraction. Instead, he sees musical structures as a matrix for creating an extensive world of imagery oriented around reality. Thereby he works with static and dynamic image sequences, then also varying their speeds. Thus on the monumental screen of the video installation *Tombe* (1997) various objects such as children's toys, pieces of clothing, vegetables, and even a person float slowly through the picture against a background of monochrome azure blue, until they disappear again at the projection's lower edge. Various tempi and long, pure shots of blue keep the viewer in a state of contemplation and expectation.

As a theme, Cahen often deals with travel through foreign cities and landscapes, as well as encounters with foreign cultures as a form of temporal experience. The journey becomes a metaphor for a temporary dynamic and flow of time that finds its counterpart in the electronic medium of video.

Sept visions fugitives is based on this type of journey, experienced by the artist in China. As a Frenchman confronted with a special tradition of colonial history he observes the everyday realities of China, as well as the culturally historic, preformulated images that the Asian land has always created among Europeans.

In seven episodes separated by Chinese numerals, Cahen audio-visually researches the country, the people, and the philosophy of the Asian cultural area. With the motif of a train in the first sequence, introduced through an extreme close-up of the eye of a young person, Cahen formulates an allegory of the unending changes of life.

He uses intentional associations and points of reference such as a bird symbolising a wanderer between worlds, the infinite space reflected in the distant landscape, the hair of Chinese women as a symbol of life, and the human face as a mirror of Asian spirituality. Narrative and symbolic elements merge together in the seven episodes.

The succession of idyllic impressions and neutral documentary images is not subject to any obvious plan, but nevertheless these images produce an apparently comprehensive picture of China through their sequencing, montage, use of colour, and merging of individual motifs. The correlation and blending of authentic recordings and digitally defamiliarised shots adequately conveys that other, incomprehensible world of Chinese thought and action.

Cahen complements the visual material with an emotive blend of noises from everyday Chinese life and the sound of Chinese music. The singing of Buddhist monks completes the circle. Ultimately viewers find themselves caught in the field of tension between real impressions of China and its mythical realities.

"The looking and listening audiences are confronted – in addition to the pure impressions – with basic questions about work (the child using a traditional device to shake the feathers from the mattress), about freedom, about life in china ... and ultimately about life and death: the burial, the bird, the man with a sheaf of straw on his back symbolizing the passage, the beyond ... I had to struggle to make what I know are stereotyped images my own. The pure impressions and raw filmic material are completely reworked, going much further than the original takes.

Robert Cahen

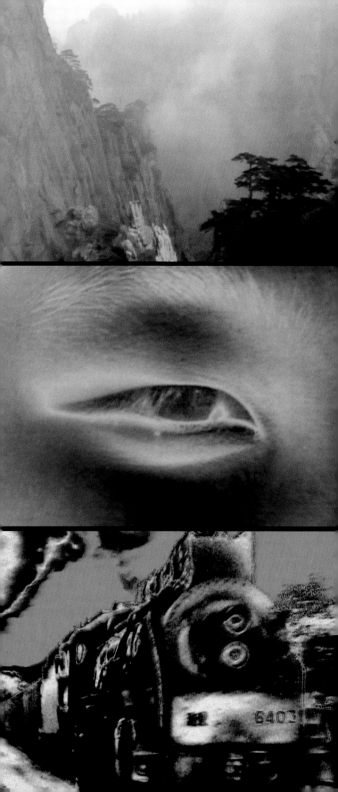

Three Transitions

Single-channel video, colour, sound, 4 min 53 sec

* 1943 in New York (NY), USA

Peter Campus belongs to the first generation of artists to experiment with the electronic medium of video. At the beginning of the 1960s he studied at the City College Film Institute in New York, and subsequently worked as a production manager and cutter. At the end of the 1960s Campus made several documentary films of exhibitions for the Metropolitan Museum of Art. In 1971 he created his first artistic videotape, *Dynamic Field Series*.

Campus' early videographic work is firmly anchored in the context of the 1970s. The technical possibilities of this still new electronic medium, and the investigation of the self in terms of its bodily and media aspects, were central topics preoccupying Campus and his contemporaries, including Vito Acconci, Joan Jonas, and Bruce Nauman. Thereby Campus was drawn to a synthesis of action, self-image, and video technology, of which *Three Transitions* is a typical example. The barely 5-minute long videotape, today a classic, was created in 1973 in the television studios of WGBH in Boston, where artists such as John Cage, Allan Kaprow, Nam June Paik, Otto Piene, and William Wegman had already been experimenting with electronic materials since the 1960s.

Three Transitions is made up of three sequences that were not originally conceived by the artist as a unit, but rather as interventions. In the first scene Campus uses a multi-level live feedback system. Campus is initially seen from the rear as a half figure in front of a light brown paper wall. He then cuts a slit in the paper, thereby recalling the Italian Lucio Fontana who had already extended art's spatial dimensions with his *Tagli* around 1960. In the video image, however, Campus cuts open not only a piece of paper, but his own body as well. He then sticks first his hands, then his arms, and finally his entire upper body through the resulting opening. In the video image it looks as though Campus is climbing through himself. The action was recorded with two cameras. One camera stood behind the actor to provide the

viewer's image; a second camera was installed on the other side of the sheet of paper to provide the corresponding rear view. The two live images were blended over one another, so that the image of a regeneration might arise out of itself. Finally Campus re-closed the cut with a length of tape, thus concluding the self-metamorphosis.

In the second transition the artist overpainted his face, stroke by stroke, with his own face once again. Using the so-called blue box technique, with which sections of an electronic image can be manipulated, Campus blended two projections of his face together. Image and mirror image coincide in one manifestation, without ever completely covering each other. So is video simply a narcissistic mirror, or does it, with self-perception, also show another person's view of one's own self?

In the final sequence Campus burns his portrait, seen as a projection on a piece of paper. Once again the artist uses the blue box technique, this time to make a sheet of paper appear to be a mirror. Only the hands of the real person behind the reflection can be seen, holding the paper and the matchstick. Finally only the black screen remains as an empty space.

In 1976 Campus stopped working with the medium of video and self-assessment in an electronic context; only in 1995, supported by computer programs, did he begin working with video once again.

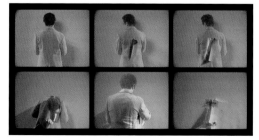

Three Transitions, 1973

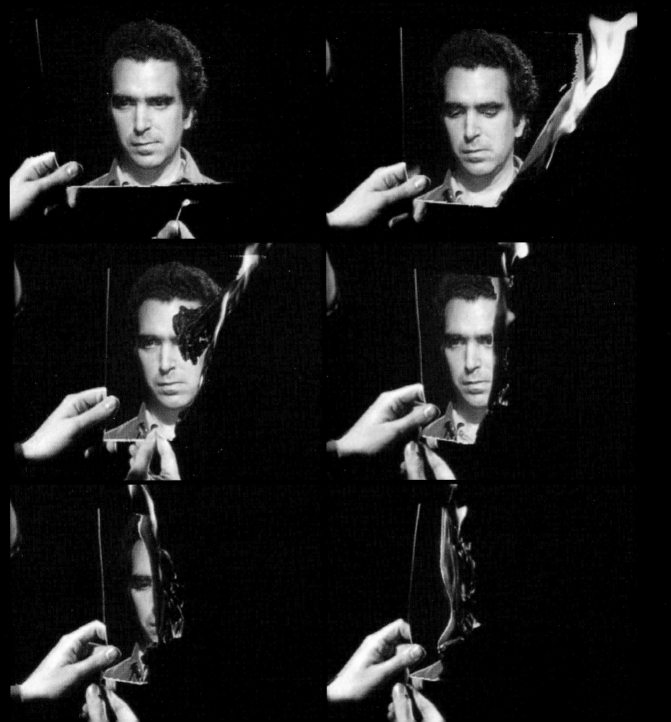

тhe Bordeaux Piece

Single-channel video, colour, sound, 13 hours

* 1969 in Kortrijk, Belgium

For several years now the line separating the genres of photography, film, and video has been blurred due to digital image editing. David Claerbout also uses the computer to defamiliarize visual materials, whether historical photographs, real recordings, or enacted scenes. In his works, however, the artist emphasizes those aspects specific to the individual media rather than negating them. By subtly displaying various technical media on one surface, Claerbout makes their characteristics perceptible to viewers. In this temporal constructions play a central role. In his latest video installations he additionally experiments with linear narrative structures as we know them from industrial films, in order to thematically deal with temporal and media-related states.

Kindergarten Antonio Sant'Elia, 1932 (1998), an early work, is a typical example of Claerbout's preoccupation with cinematic and photographic image strategies. An old black-and-white photograph showing children playing in the courtyard of a kindergarten served as his model. In keeping with the medium of photography, the lively situation appears as though frozen. The paper print stands for a reality that belongs to the past, a fact emphasized by giving the year 1932 in the title.

Upon closer observation, however, the leaves of the two trees can be seen to be swaying gently in the wind. With this minimal intervention the artist introduced cinematic movement into the static image, making the historical photograph suddenly come intensely alive. Thus two different media structures, each connected with different expectations, encounter each other in the video projection. Once the movement in the trees has been pinpointed, the notion immediately develops that the children could also continue their game.

In *The Bordeaux Piece* Claerbout develops the temporal structure even more complexly. Here he uses the form of narrative film, also for the first time employing language as a means of composition.

The story tells of a classical, melodramatic relationship between two men – father and son – and a young woman. The protagonists meet in a cool house of modernist design, located in an idyllic landscape. The view across the landscape, shown at the beginning and at the end of the single-channel video projection, provides a clear framework for the narrative. Then the film appears to loop, and the dialogue and action seem to start over again. In fact, however, the actors are starting the scene from the beginning over and over again. Only by watching the video for a longer period of time may viewers become aware of the passing daily cycle from sunrise to sunset that forms the real-time backdrop to the piece. The entire length of the work is 13 hours.

While this interlacing of two temporal systems – the fictitious time of the story and the real time of the day – is already extremely complex, Claerbout plays a further double game with the video's soundtrack. By making the spoken words audible only through headphones, he separates the sounds of the landscape from the dialogue of the people. Without headphones viewers can hear only the natural sounds such as birds and insects. When they put the headphones on they can then understand the dialogue, but this also pushes the rest of the acoustic material into the background. The spectrum of sounds additionally corresponds to the course of the day, whereas the acted story defines and repeats its own temporal framework.

Kindergarten Antonio Sant'Elia, 1932, 1998

Journey into Fear

Single-channel video, colour, sound, 15 min 22 sec per sequence, 30 dialogue channels, in total 460 min

* 1960 in Vancouver, Canada

Vancouver, the home of Stan Douglas, is not only the most important trade and transportation junction in Canada, but has additionally been a centre for film and television production since the 1930s. Jeff Wall is also among the numerous photo artists living here. Douglas, who primarily works in film format, uses complex narrative structures to reflect upon media history, simultaneously tracing a picture of society that appears just as genuine as it is abstract. *Journey into Fear* follows two film interpretations of the 1940 novel of the same name by Eric Ambler. Ambler tells the story of a weapons dealer named Graham, who has set up a deal in Turkey. An assassination attempt is carried out on Graham. His adversary Möller wants to delay the deal in order to give Germany an advantage in the Second World War. The conspiracy is exposed in the end.

The gripping story was first filmed in 1942, and a remake filmed in Vancouver in 1975. The context had changed, however: while the Second World War had served as the political background for the first film, in the remake the oil crisis of 1973 provided the backdrop for the intrigues. Social conditions had fundamentally changed: since the 1970s power had lain less in politics and much more in international financial capital.

In Douglas' version of *Journey into Fear* the two protagonists also meet on a ship. The role of Graham is played by a woman who is a ship's pilot, and Möller has become a freight supervisor. During two film sequences a crude dialogue develops in which Möller, as the schemer, tries to involve Graham in his conspiracy. In a cabin on the ship they discuss purchasing gold, the deliveries of medicine, and the difference between a rogue and a fool. They also speak in innuendo about the journey's delay in reaching its final destination. If the ship arrives at its intended harbour late, Möller's partners will make a profit of 75 million dollars.

Two chase scenes are shown between these two blocks of dialogue. Graham searches for something in her luggage, without finding it; she leaves her cabin and meets Möller in the gangway. Möller then follows Graham all the way to the upper deck. In the second scene Möller follows Graham as she goes through the loaded container ship. Graham has discovered a piece of material hanging out of one of the containers, on the label of which can be read "Made in Singapore". She returns to the cabin, while Möller inspects and seals the telltale container. These four sequences are repeatedly shown in this order, yet the spoken texts change. Five variations of dialogue exist. When the scene changes a computer decides, based on the principle of random selection, which dialogue will be played. Furthermore, there are two different variations of each scene of the film's plot. This creates 625 possible combinations, all different, of pictorial sequence and dialog. In his interpretation of *Journey into Fear*, Douglas condenses the story into an abstract game of intrigue, power, mistrust, and calculation.

"'Journey into Fear' is an endless, cyclical voyage but, as one gradually becomes aware of its structure, one can at least intuit how the future became history."

Stan Douglas

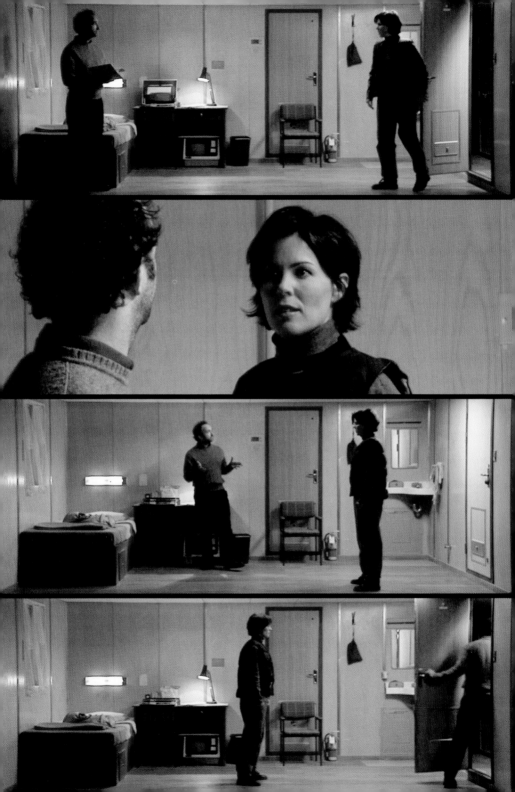

schnitte.
Elemente der Anschauung

Single-channel video, black-and-white, sound, 10 min

* 1940 in Linz, Austria

At the end of the 1960s, when a primary concern was the reactionary structures of thought of post-war society, VALIE EXPORT took up a position within the circle of the Viennese Actionists. Her artistic goal was provocation and, in connection with this, the radical expansion of artistic means. EXPORT is a Performance artist, Media art pioneer, photographer, "linguist", and much more. As a woman, she examines the way our society is characterized by patriarchy, and the fixed sexual-role structures which were to be shaken to their roots.

EXPORT's preoccupation with the mass media and new technological means began around 1966/67 with her work in Expanded Cinema (which abandoned classic auditoriums and common systems of presentation, in order to reinvent them). In *Ping Pong* (1968) she freed cinema-goers from their passiveness as consumers; here they could score points on the canvas with a table-tennis paddle and ball.

Among her most spectacular actions is the *Tapp- und Tastkino* (Tap and Touch Cinema, 1968). Here the field of experimental film overlaps with the artist's feminist-actionist concerns. EXPORT wore a little cinema box in front of her bare breasts. She travelled through the streets of various cities wearing this, and offered passers-by the opportunity to reach into the box for a short moment and feel her breasts. Instead of the sense of sight, the public's sense of touch was challenged, and at the same time the cinematic role of women as sex symbols was presented. With her drastic attitudes and actions, EXPORT dismantled clichés of femininity again and again.

In 1970 EXPORT produced her first video work, *Split Reality*. The installation was based on a concept from 1967, and was referred to as a video poem. A monitor shows the artist wearing headphones and singing a song in front of a microphone. The viewer hears only the song performed by EXPORT, not the original. In the years that followed she created numerous video performances, 8-mm films, so-cal-

led "visual texts", and much more. In 1984 she produced a 90-minute feature film called *Die Praxis der Liebe* (The Practice of Love).

In the mid-1970s EXPORT created a tape entitled *Schnitte. Elemente der Anschauung* (Cuts: Elements of Observation). It was a videographic equivalent to photographs such as *Zeitgedicht/24 Stunden* (Temporal poem/24 hours photographed 24 times, 1970), which succinctly demonstrated the conceptual approach. With her video camera EXPORT followed an imaginary line that she had drawn through a housing block – a multi-storey building from the Wilhelminian period. Exterior shots alternate with shots of the interior walls of the apartments. This is followed by a cut. In a serial sound montage, every window of the housing block becomes a loudspeaker. Subsequently an interior is to be seen, but the soundtrack plays outdoor noises. This situation is reversed in the following scenes.

The video *Schnitte. Elemente der Anschauung* documents not only the artist's conceptual strategy upon which all her works are based, but also her early interest in spatial constructions, architecture, and public space. Later, in the 1980s, EXPORT used digital techniques combined with the human body to further develop these elements, forming a surreal synthesis.

Tapp- und Tastkino, 1968

Lock Again

Single-channel video, colour, sound, 3 min

* 1971 in Peking, China

The opening of the People's Republic of China to western business and culture has over the past decade, significantly contributed to numerous Chinese artists, above all writers and fine artists, being able to both operate and be discussed in the international arena. Yang Fudong lives and works in the booming metropolis of Shanghai which, due to its liberal politics and economic expansion, is an ideal mirror of the country's socio-cultural changes. In his photographic works, films, and videos, Fudong tells mysterious stories about people who are searching for themselves. For him, reality and fiction coincide, and this is the rationale for a strange surrealism. One can surmise pictures of the unconscious and metaphors for life behind every scene, behind individual motifs, and behind the emotionless expressions and gestures of the protagonists.

In this way Fudong combines traditions of China, such as its allegorical language, with contemporary themes and technical capabilities. He is a part of a young, media-competent generation that has grown up with Hollywood classics and an awareness of cinematic history. Finally, film has also played a central role in Shanghai's cultural life since the 1920s and 1930s.

Lock Again is a 16-mm film, but its experimental character, known from classical video, lies in its short playing time of three minutes. The opening scene already hints at the film's intention. A man sits slumped in the corner of a bleak room. A cropped shot of a bed is the only other thing to be seen. The scene radiates fear, hopelessness and weariness. The second scene follows a hard cut, and shows two young men in 1970s police uniforms. One lies sleeping in the bed, the second bends over him. He appears to be searching for something in the other's clothing. Their faces show traces of a fight. "Sometimes", says Fudong, "violence and death are the places life comes from: they fill life with more hope."

In further shots the two are seen in inhospitable places: in machine rooms, in the jungle, and in deserted courtyards. In one of the first sequences of the film a young woman awakes from sleep in a garden – a place that, in China, serves as a social meeting place and place of relaxation. The police find themselves on the run and take the girl with them. In a rowboat they travel on a lake, and in a kind of indoor swimming pool, without actually escaping from their imaginary pursuers. Initially the protagonists seem uneasy and somewhat harassed, but they take up the fight. This condition changes in the course of the sequence, and at the end they seem more resigned and without hope.

Fudong forgoes any dialogue in this film. Only minimal background noise provides a subdued acoustic atmosphere. The individual shots, alternating quickly and abruptly and laid out in spectacular chiaroscuro, seem like metaphorical Tableaux Vivants. Although the characters perform actions, their movements and facial expressions seem rigid and unnatural, and they appear to be as much theatre scenery as their surroundings. The piece closes with the unfulfilled hope of "true beauty" (Fudong).

> **"A concept that still preoccupies me: one wants to accomplish big things, but in the end it doesn't happen. Every educated chinese person is very ambitious, and obviously there are obstacles – obstacles coming either from 'out there', meaning society or history, or from 'inside', from within oneself."**
>
> **Yang Fudong**

sturm

Multi-media installation

* 1965 in Strasbourg, France

Dominique Gonzalez-Foerster furnishes spatial units with various details such as photographs or personal possessions, and it is not unusual for these interior spaces, with their obvious artificiality, to be reminiscent of film sets. With these units Gonzalez-Foerster is designing biographical zones, which viewers must successively investigate and make associations with. A story develops that could not be created without the recipients, who look curiously about the room. "Rooms contain, among other things, half 'subconscious' exhibitions of the self", says Gonzalez-Foerster about the interiors she designs.

While details in this type of room installation create an individual situation, in the series *Séance de Shadow* (late 1990s) Gonzalez-Foerster uses colour and light to immerse rooms in a uniform atmosphere. Only a few objects – chairs, beds, lamps – define the setting as a living area. In *Séance de Shadow II* (1998), which could be walked through at the 48th Venice Biennial, the artist dispensed completely with props and laid the room out as a passageway. The various blue tones of this passageway transported visitors into a Blue Box – in film production a blue room, the background of which is able to be exchanged, and which is thus an empty space to be filled later.

In various ways, media production formats and structures repeatedly play a central role in Gonzalez-Foerster's spatial constructions. On the one hand, the artist made a 10-minute, 35-mm film called *Central* (2001), in which she confronted the public space of the exploding metropolis of Hong Kong with the situation of an individual woman. When this woman, like the *Monk by the sea* (ca. 1808/09) in the painting by Caspar David Friedrich, is shown alone and from behind, facing Hong Kong's gigantic skyline, feelings such as loneliness and despondency are evoked. Man dissolves within the superior power of his environment.

In the multi-media installation *Sturm* on the other hand, Gonzalez-Foerster sets up a feedback system that turns the viewer into an actor participating in the production of media images. Various devices stand around the room, in sound and image as well as on a tactile level simulating a storm. Fans create an intense wind, stage spotlights with blue gel produce a tempestuous light, a stroboscope produces lightning, and the noises of wind and rain play over a sound system. Both this atmospheric simulation and the camera are focused on a point at which viewers position themselves. Once they step into this perspective, their images appear on two monitors sitting on the table together with other technical equipment such as a sound mixer and amplifier system. A third monitor is placed in such a way that the actor can view him- or herself in it. Although everything is reminiscent of a film set, there is no film being shot here, nor are images being transmitted live as in a television program. The electronic images exist only within the closed circuit. They are neither conserved nor made available to a broader public.

With *Sturm* Gonzalez-Foerster has designed a contemporary form of the media surveillance system, a topic that has recurred again and again since Video art began in the 1970s. In simulating a recording studio she not only critically demonstrates the conditions and capabilities of film and television, but she also creates a situation that allows viewers to personally experience the grand illusion of media images.

Cette fille en noir, c'est le monolithe de 2001, L'Odyssée de l'espace

Central, 2001

Twenty Four Hour Psycho

Video, black-and-white, without sound, 24 hours

* 1966 in Glasgow, UK

Seeing familiar things anew, and tracing their physical and emotional backgrounds, is Douglas Gordon's most pressing artistic aim. Gordon is part of a young generation of British artists who were able to garner international success within the last few years, and whose works, such as those of Smith/Stewart and Gillian Wearing, are marked by extreme emotional forcefulness. In his films, videos, photographs and textual work, Gordon repeatedly isolates details in order to uncover functionality and context. Thus in a black-and-white photograph entitled *Tattoo* (1994) Gordon shows only the arm of a man, upon whose upper arm the words TRUST ME can be read. Clichéd ideas about the sort of people who have tattoos collide directly with the demand of confidence, and reveal hidden prejudices.

In his video installations Gordon generally uses found footage that, in the tradition of Duchamp, he processes into a cinematic ready-made. Through repetition, slow motion, and enlargement, the artist defamiliarizes the audio-visual material and thereby directs one's attention to temporal constructions, the faculty of memory, and expectations.

Besides scholarly historical documentaries Gordon is primarily interested in Film Noir classics, with which he is familiar from the night-time programming of British broadcaster Channel 4. Therefore it is not the darkened cinema with its rows of seats and giant screen that makes up Gordon's place of reception, but rather his own flat, bed, and the many familiar objects collected in his home: "… most of the movies that I've watched, I've watched in bed rather than in the cinema … It was not exactly the social context but the physical context of watching that knitted together all of my experiences …"

It was out of such a situation Gordon created one of his first video installations, *Twenty Four Hour Psycho*, in which he alludes to a classic film. "Psycho", filmed in 1960 by Alfred Hitchcock, is more than just a source of found imagery for Gordon. He appropriates the entire story, in which one now-iconic shot follows the next, and stretches it to a playing time of 24 hours. Installed as a large freestanding projection, viewers must spatially position themselves around it, meaning that it becomes unavoidable for them to appear now and again as shadows on the screen – just as, in every one of his films, Hitchcock has a tiny guest appearance.

By being temporally stretched, the film plays in extreme slow motion. Changes in images occur almost imperceptibly, and the sound can no longer be identified. The plot appears to barely progress, so that an audience familiar with the details of the film classic must mentally add foregoing and succeeding events to the moment of viewing the image – that is, completing the story either before or after it has taken place on screen. Thus various time dimensions – past, future and present – consolidate into an amplified experience of time.

It is only in the medium of video that this type of streaming deceleration is possible. The celluloid roll of the film's original format is made up of a sequence of individual shots, and only the fast mechanical action of the spool produces movement; a slowed-down spool of film would result in flickering and, although it would show changes in small steps, these would be abrupt. Gordon's conversion of film to video allows every moment of the film to remain as an icon, simultaneously leaving the flow of pictures uninterrupted.

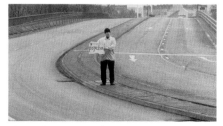

Psycho Hitchhiker, 1993

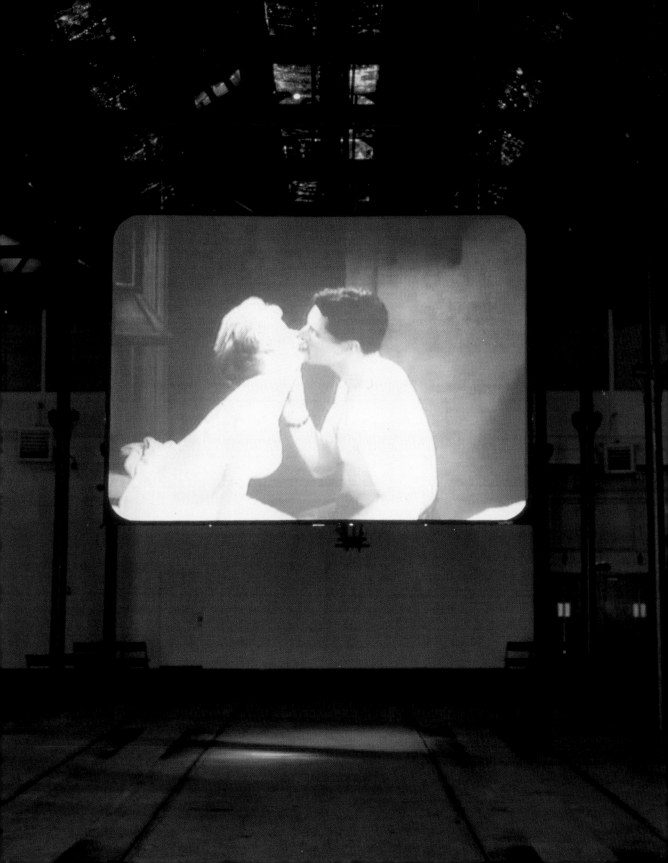

video piece for two glass office buildings

Live feedback installation (2 monitors, 2 cameras, mirror)

* 1942 in Urbana (IL), USA

Dan Graham has aptly described the attitude which fundamentally characterized art of the 1960s and 1970s: "A premise of 1960s modernist art was to present the present as immediacy – as pure phenomenological consciousness without the contamination of historical or other a priori meaning. The world could be experienced as pure presence, self-sufficient and without memory." Thus in his early work he investigates "pure presence" in the context of architecture and video. To him both fields represent types of codes giving information about social orders and one's own self-esteem. Therefore in Graham's work public and private spheres meet in ingenious video installations that confront viewers with themselves.

Video Piece for Two Glass Office Buildings is a typical example of this. With a live feedback system of the kind he predominantly used in his early work, Graham takes over an urban space. Two identical offices lying across from each other in two buildings, the façades of which consist primarily of glass, form the architectural prerequisites for the installation. In each of these rooms a mirror wall is installed parallel to the windows, and these walls reflect the space between the mirrors, including occurrences outside the building. A monitor with an attached camera is additionally placed in front of each wall of windows, and the camera transmits the reflected image onto the screen. The camera image from the left-hand building is thereby transmitted live onto the right-hand building's monitor, while the camera image from the office on the right is shown, with an 8-second delay, on the left-hand building's screen.

This intertwining of inward- and outward-looking views, and of real and media presence, creates a perspectival field in which the subjective, one-dimensional viewpoint loses importance. Viewers, who can only experience the work from within this field, see themselves located in both the public as well as the private realm. They are confronted with complex urban and media structures, and must assert their own standpoint within these. "The feedback", says Graham, "creates both a process of continuous learning and the subjective sense of an endlessly extendible present time in flux, but without a fixed future or past states."

The combination of architecture and video has occupied Graham in his later years as well. In 1981 he designed a model for *Cinema*, the façade of which was partly made up of mirrored glass, and which permitted glimpses both into and out of itself under certain lighting conditions. In the mid-1980s Graham developed, for the presentation of videos, a functional room design that simultaneously served as an artwork, because the reflecting panes of glass initiated an optical-critical knowledge process.

When Graham compiled the almost 1-hour video *Rock My Religion* between 1982 and 1984, in which he placed in one context, among other things, the religious community of the Shakers and the Rock 'n' Roll worshipping youth movement of the 1950s, the artist moved away from the dogma of the "pure presence", and reintroduced historical memory into his art.

"My intention is in opposition to the historicist idea that everything we know about the past is dependent upon the interpretation of the fashion of the present."

Dan Graham

incidence of catastrophe

Single-channel video, U-matic, colour, sound, 43 min 51 sec

* 1951 in Santa Monica (CA), USA

At the beginning of the 1970s, Gary Hill experimented with the technical possibilities of a video image in a feedback system. Like Steina, Woody Vasulka, Nam June Paik, and Ed Emshwiller, he was interested in the electronic process of image creation. Thereby he used synthesizers to create artificial images. When Hill began to write at the end of the 1970s, he had already discovered the two areas which were to significantly characterize his further work. Again and again he allowed the linguistic system of speech and the electronic system of video to enter into dialogue with one another. Hill has implemented formal structures like reversal, stretching, or compression, which correspond on a textual and audiovisual level, to create impressive word images. Thereby he continues a conflict between word and image that was initially taken as a theme in cubism and surrealism, and then continued after 1945 by representatives of concrete and visual poetry, and by Conceptual and Land art artists.

In an early work like *Windows* (1978) Hill demonstrated the potential of video images that had been manipulated by feeding in additional electronic signals. The media image's process-related characteristics are thereby a significant part of the work. In *Windows* he defamiliarizes a real-time shot of a window – a motif that has existed since earliest art history. The changes in coloration and contrast create transparent colour fields that defamiliarize the spatial situation, the interior and exterior, to the point of unrecognizability. Finally the picture breaks up into its component pixels, and the surface begins to energetically pulsate.

While Hill is primarily preoccupied with the electronic syntax of the medium of video in this piece, in *Incidence of Catastrophe* a complicated context is also formed by language, text, media images and – for the first time in his work – the human body. The work is based on the novel "Thomas the Obscure" by Maurice Blanchot (1941; revised version 1950). This is the story of a man, Thomas, who loses himself more and more in the story of a book, until he not only mentally but also physically disappears. The novel starts with a memorable scene: "Thomas sat down and looked at the sea. He sat motionless for awhile … then, as a … wave touched him, he descended … the sandy bank, and slid into the midst of the wave, which crashed over him."

Hill himself plays the protagonist in the video. Sequences with running water, sea, and eroding sand dunes, overlaid with words and fragments of sentences, illustrate the novel's various motifs and at the same time the powerful attraction of the text. Thomas appears repeatedly in individual episodes within these suggestive series of images: reading from a book, losing himself in it, and finally struggling for his identity. The conversation at a dinner party, in which Thomas also participates, becomes bogged down in an incomprehensible accumulation of words. The flow of dreamlike, hallucinatory word images, and Thomas' attempt to free himself from them, ends by making him completely distraught.

He lies in his own excrement in the foetal position on a white tiled floor. The opened book towers monumentally before him, and seems to want to crush him between its pages. A long stick, on which the camera is fastened, prods the defenceless body again and again, and with this gesture consummates the reader's helplessness against the words and images.

Windows, 1978

Impressions

Single-channel video, colour, sound, 10 min

* 1931 in New York (NY), USA

The American artist Nan Hoover painted for many years, and only began working with the medium of video in 1973. In 1969 she had moved to Europe and established her international reputation as a Video artist there. From 1986 to 1996 she taught video and film at the Art Academy in Düsseldorf, and there, along with Nam June Paik, was one of the most important sources of inspiration for a young generation of artists.

In her videos, installations, and performances Hoover incessantly investigates the phenomena of light, movement, and space: things that can only be suggested in painting. Video, however, is based on processing pulses of light in either analogue or digital signals; the transmitted video image, on the other hand, represents an energetically vital surface that is continually changing. Unlike the medium of film, no single, fixed shots exist in video. A so-called frame, a single shot in the pictorial sequence, can only be artificially created if one brings the video to a standstill by using functions on the playback device. Light and movement, both of primary interest to Hoover, are thus essential aspects of the medium of video. In regard to her understanding of space in this context, the artist once explained in an interview: "Important here is the luminous character, i.e. the manifestation of light as volumes, as bodies. ... light as an independent body."

In Hoover's work, video-specific characteristics correspond to her artistic intentions. Thus she creates works that exhibit a clearly painterly character. With this in mind, she also avoids cuts and montages. Television as a mass media, as it was critically reflected upon or appropriated by artists in the 1970s, does not interest Hoover. Nor did she allow herself to be caught up in the technology euphoria, and in a sense she works with the video camera in much the same way as she would with a brush.

The early video piece *Impressions* is a typical example of her artistic approach and her technical insight. As she so often does, Hoo-ver used a macro lens, with which she takes close-ups of human bodies and objects. In *Impressions* she uses a camera in a fixed position to focus upon a hand, the index and middle finger of which seem to draw a line of spaceless blue light. The wrist cannot be seen in the picture. This makes the hand appear like an organic instrument, with no connection to an individual body. A beam of light shines upon the two extended fingers. The movement of the hand in the radiance of this beam creates a distribution of light and shadow that produces a narrow, bright strip. This creates the impression that the fingers, like a drawing pencil, are defining the line. The physical gestures and quiet movements that Hoover also employs in her performances give the videos a sense of being temporally closed.

"Right from the beginning I was only interested in the continuity of the path from A to B: in a space-time continuum. For me video was comparable to the way in which one looks at a painting."

Nan Hoover

Light Poles, 1977

Les incivils

Single-channel video, colour, sound, 40 min

* 1962 in Paris, France

Pierre Huyghe belongs to a young media-proven generation of artists who, since the 1990s, have been explicitly dealing with the formats and circumstances of film and television. In 1999 through a commercial exploitation company in Japan, Huyghe, Philippe Parreno, and Dominique Gonzalez-Foerster jointly purchased the rights to the prototype for a computer-generated animated figure, and gave it a personality. Annlee became a leading actress who spoke principally about the history of her own media-bound construction.

The main emphasis of Huyghe's work, however, lies in the re-making of well-known film classics, whereby he draws his viewers' attention to the films' structures and original contexts. However, instead of becoming a video analysis or documentation, his more recent re-makes have been turning into cinematic narratives in which the main role is played by changes in time and space, as well as by perception itself. Thus in *Remake* (1994) Huyghe recapitulates the Hitchcock classic "Rear Window" (1954) in the form of a home movie. Amateur actors faithfully re-enacted the original over only two weekends. Camera positioning and cuts were likewise adopted. The protagonists of the film who replace James Stewart and Grace Kelly found themselves in the unusual situation of simultaneously acting in front of the camera, and having memories of the scenes from the cinema screen. They define the difference between film and reception, and in the form of media embody the act of perception.

In *Les incivils* (The disobedient ones) Huyghe takes up a film by the poet and director Pier Paolo Pasolini, who gave Italian Neorealism new inspiration in the 1960s. In Pasolini's "Hawks and Sparrows" (1966) a father and son, played by Totò and Ninetto Davoli, travel through provincial Italy and approach the periphery of a city. A talking raven joins them, and dialogue about political and philosophical questions develops. His home, as the raven says at one point with a sar-

castic undertone, is ideology, and he lives in the metropolis, the city of the future, in Karl-Marx Street. The crisis of Italian Marxism in the 1950s formed the real political background for the original film. Interestingly, Pasolini added a temporal displacement to the narrative, by placing his two principal actors in the Middle Ages and making them brothers of Saint Francis Assisi.

Huyghe also used this type of temporal leap as a theme in his reflection of the film. He did not turn to the past, however, but rather – from the original film's point of view – to the future. Huyghe returned to the originally used locations, followed the same paths once again, and introduced people presently living along the route. Ninetto Davoli played his role once again, and now expanded on it. The shots now showed the changes that had taken place up to the time of the 1990s filming. Moreover Huyghe displayed places which refer to Pasolini's life, such as the beach at Ostia where the filmmaker was murdered in 1975. Then the unavoidable double time-lag developed, as the two protagonists from the present time were shifted into Pasolini's film time, the 12th–13th centuries.

With *Les incivils*, Huyghe has constructed an intricate interplay between real and media-created structures of space and time, which sheds an impressive light on changes in culture and society.

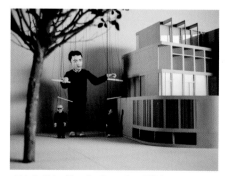

This Is Not a Time for Dreaming, 2004

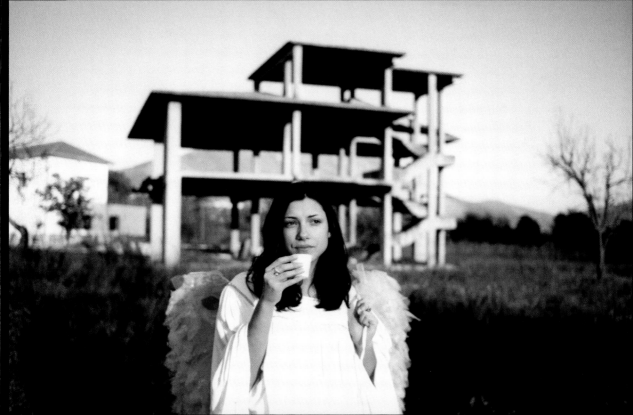

Jones Beach Piece

Performance filmed on video

* 1936 in New York (NY), USA

A stimulating inter-relationship has existed between Video and Action art since the 1960s. Thereby the electronic medium has been allocated various roles: it acts as storage, as a mirror, as a window, and also as manipulated material. Joan Jonas, a pioneer of Performance art, employs video as a complex means of expression in her actions, and in the 1970s went a distinct step beyond the earlier, reductive approaches of artists such as Bruce Nauman and Vito Acconci: "Video is a device extending the boundaries of my interior dialogue to include the audience. The perception is of a double reality: me as image and as performer. I think of the work in terms of imagist poetry; disparate elements juxtaposed … alchemy."

Jonas' artistic background makes the multilayered aspect of her work comprehensible: she studied art history and subsequently trained as a sculptor. The radical dance performances of Yvonne Rainer and the Judson Dance Theater, who sometimes integrated films into their presentations, have been available to audiences since the early 1960s in New York, where Jonas lives. At the end of the 1960s, Jonas herself took dance instruction. Through the sculptor Richard Serra she became familiar with early avant-garde film, becoming enthusiastic about Russian film directors such as Dziga Vertov and Sergej Eisenstein, and about early French films, including "The Children of Paradise" (1944) by Marcel Carné. She was also impressed by foreign cultures, whose archetypes and rites she came to know on her travels. She became a "researcher of myths" in the sense formulated by Harald Szeemann with his exhibition "When Attitudes Become Form" in Berne in 1969. Jonas draws her creative potential out of these varied approaches.

In the actions, which take place within interiors, she links together various media and objects that are loaded with symbolic meaning and fulfil various functions. Her own movements, as well as the electronic moving pictures, follow a rhythmic and ritual choreography. Corresponding to the action, she also develops a sound design from tones, noises, and so on.

Mirage resulted from impressions of a journey to India, and represents a preliminary conclusion in her series of mythological-symbolical performances. It is the last action in the black-and-white series, in which she integrated two earlier actions, *Funnel* (1974) and *Twilight* (1975). It was followed by an intensive preoccupation with the world of fairy tales. In a stage-like room the artist set up a table, a blackboard, a film screen, an oversized metal funnel, a mask, and a monitor placed on the edge. Within this field of objects, built up with no central reference point, Jonas acts − sometimes with, sometimes without − the moveable elements. She reads a fairy tale aloud above the metal funnel, performs a stamping dance ritual, plays the child's game "Heaven and Earth", runs on the spot, holds the mask in front of her face, and squats upon the monitor. The television screen shows the earlier action *Twilight*, in which Jonas strides through a wooden hoop − here a metaphor for the screen. A vertical beam that runs through the media image follows the rhythm. At times, the large film screen in the background illuminates the venue of the action. It also, however, shows documentary material of a volcanic eruption. For another scene, Jonas filmed herself drawing figures upon a blackboard with chalk − symbols for sun, storm, or love − and then erasing them again. Jonas later reworked the first version of *Mirage*, using both new material and material from the original performance.

In the performance *Jones Beach Piece* at Jones Beach, Long Island, she played on the dislocation between sounds and signs sent from afar − the differences, for example, between an audience seeing performers clapping wooden blocks together and bearing the resulting sounds after a slight delay.

Bossy Burger

Single-channel video, colour, sound, 59 min 8 sec

*** 1945 in Salt Lake City (UT), USA**

Paul McCarthy has been working in the field of performance for more than three decades. He was one of the most important artists from the West Coast of America in the 1970s, whose actions significantly influenced a young generation including Mike Kelley, Jason Rhoades, and John Bock, and yet his complete works have only recently been receiving the international recognition due to them.

Again and again, McCarthy attacks deeply rooted clichés and behavioural norms through his works. He dismantles the image of the wild west that is equally glorified in both America and Europe, he puts Disneyland's idealized world under pressure, and in dealing with topics in his work like sexual intercourse, masturbation, rape, or child abuse, he attacks established ideas of decency and morals. The methods he uses to achieve this get under one's skin, and can be offensive. McCarthy acts as if possessed in front of the camera. He exhibits infantile traits as when, for example, he smears about liquids like ketchup or urine; he mutilates himself – or rather ersatz body parts made of plastic – as well as wrecking the scenery in which the action takes place. He shouts out loud, urinates in the corner, and altogether makes a gigantic mess, which places the viewer in a state of emotional tension somewhere between amusement and revulsion.

McCarthy's work initially developed from painting. He interpreted as actions the painting of the late 1960s and 1970s, and from this basic approach has incessantly developed new performances. In *Whipping a Wall and a Window with Paint* (1974) McCarthy strikes out around himself with a big piece of cloth dipped in paint. The empty room with the window facing the street is marked by the traces of this movement, which is inevitably reminiscent of the drippings by the Abstract Expressionist Jackson Pollock. Recorded in black and white, however, the film negates any colour component of action painting. Here McCarthy, who usually prefers hand cameras, uses a still cam-

era, repeatedly changing its position. It is typical of this early phase that McCarthy performs in front of an audience – in this case passersby on the street.

Bossy Burger marks a turning point in the artist's work. This is the first performance in which McCarthy used a film set. The narrative is thereby provided with a fixed, pre-structured location. In 1991 the artist acquired the TV-studio set of a hamburger restaurant called Bossy Burger from the American sitcom "Family Affair". McCarthy installed the set in the Rosamund Felsen Gallery in Los Angeles, using a full range of professional TV equipment to record his actions there for one day, during which he strictly excluded the public. He edited the material for two days, and then showed the one-hour final cut of the performance on two monitors amongst the ruined scenery.

McCarthy employed his entire performative repertoire. He appeared dressed as a cook, thereby wearing the mask of the "Mad" magazine icon Alfred E. Neuman, and smeared various food and liquids around to produce a great mess. He produced, among other things, a hysterical emotional outburst, cut the tips off two fingers of his gloves, demolished the furnishings of the set, and painted penises on pieces of paper.

With this work, McCarthy severely criticizes American eating habits, and by using a set from a TV series he simultaneously illustrated the way in which media mechanisms function. The remnant of the studio set is not only a relic of a past action, but is also the starting point for a further performance in *Bossy Burger*.

Whipping a Wall and a Window with Paint, 1974

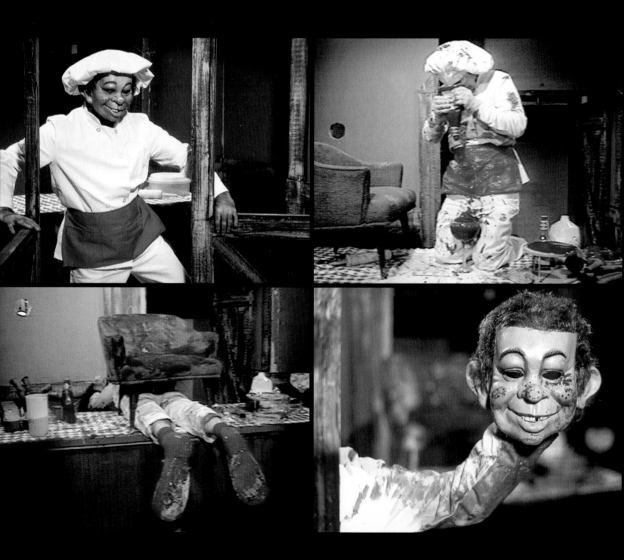

Again & Again

Single-channel video installation, 8 monitors, colour, sound, 5 min 40 sec

*** 1965 in Kirchheim/Teck, Germany**

The questioning and definition of one's own identity has been a main thematic emphasis of Video art since its early days. The electronic medium acts as a mirror, as well as an instrument suitable for observing people in their relationship to audio-visual media reality. While artists in the late 1960s and 1970s primarily used the circular feedback method to search for traces of the self, towards the end of the 20th century they expanded their spectrum with narrative, as well as with documentary-dissecting methods in which the subject is isolated from the cultural and media crossover of today's society.

Bjørn Melhus has been enriching the art scene with his films, videos and installations since the late 1980s. In narrative form he seeks the biological components of the search for identity. Melhus thus negotiates the jump from childhood into the world of adults, or the situation of twins. In both cases the body finds itself in exceptional circumstances: in one it passes through a hormonal metamorphosis, in the other the human organism exists in duplicate, and therefore is subject to constant comparison.

Melhus clothes the essential question about the self in a narrative structure. The story is performed like a piece of theatre. The artist films within sets such as those used in film and television, but he takes on almost all the roles himself. In *Weit Weit Weg* (Far far away, 1995) he slips into the figure of the little girl Dorothy – based on the film "The Wizard of Oz" with Judy Garland – who uses a mobile telephone in her attempts to procure a double. Through the grotesque casting – a grown man as a young girl – an undertone of humour or even sarcasm inevitably arises, typical of Melhus' work.

In *Again & Again* Melhus deals with the theme of artificial reproduction, which has triggered a continuing discussion about the biologically feasible and ethically acceptable capabilities of medicine since the time of Dolly, the first cloned sheep. In the video installation the artist visualizes the demise of the individual against the backdrop of genetically engineered reality. The eight monitors lined up next to each other already hint at the possibility of infinite duplication.

In the opening sequence a pale-green variable light beam, accompanied by synthesised sound, passes through the row of monitors. Than a person appears on the screens – the artist as an already standardized prototype – who begins a dialogue with himself: "Look at this, this is a great opportunity." He is referring to the possibility of duplicating himself from himself, and would like to know how a future like this could appear. Before the reproduction begins, the figure's self-renunciation is demanded by an off-camera voice chanting the words "kill, kill, kill, kill". The bass rhythm of the pop song "You are not alone" by Michael Jackson begins. The protagonist dissolves in a green beam of light, which subsequently doubles. Two clones are created from this; they are completely filled with enthusiasm about themselves and demand further reproductions. The creator consents, and unchecked reproduction – "and again and again" – begins. At the conclusion the army of clones has usurped power, and the "first" person finally dissolves in a beam of light. Then the film loops, and everything starts again from the beginning.

Melhus uses all of video's technical possibilities to artificially create double or even multiple identities, such as when he presents himself, for example, as a twin. By this means his work constantly combines the amateur quality of his role-playing with the artificial quality of video technology.

No Sunshine, 1997

Dispersion Room

Video installation

* 1962 in Groningen, Netherlands

An open-plan office: clerks dressed in a distinguished manner sit in front of computers, clutch file folders, wander around, or make telephone calls, seemingly bored. The camera eye affixes itself to a person, loses that person again, or becomes distracted and follows another detail. Action as well as image choreography seem uncoordinated; they make no sense. The overly cool office ambience is filled with blind activity, which gives this ordinary, everyday scene an absurd character. A group of Asian visitors mix amongst the uncoordinated office employees. Rolls of cable lie on the ground, and a man on a ladder works on the room's ceiling. The system seems to be coming apart at the seams. Women and men squat on the ground and stare indifferently about, others band together in an agitated crowd, without the reason becoming apparent. Then the double projection loops, and the chaos begins over again.

As in many of his multi-media works, in *Dispersion Room* Aernout Mik presents people in an unfettered state, freed from social conventions. Instincts and unconscious reactions determine their behaviour, and redefine the self on an unfamiliar, body-related level. To reach such a state, Mik provides layman actors with a rough game plan, places them in surroundings adequate for the plot, and then leaves them to come up with their own improvised and unforeseeable reactions. Under conditions like these, social systems can no longer function. Individuals and society stand in irreconcilable opposition to each other, and produce an absurd situation that seems simultaneously humorous and shocking. This is also the case for the old men in *Kitchen* (1997), who beat each other with clubs in a sterile kitchen. A tragi-comedy is acted out, the background of which remains unclear.

The unfettered, intuitive behaviour of individuals in a defined social framework transforms the events in Mik's video installations into an uncontrollable flow of actions. This flow, in which the body plays a central role, allows the artist to reach into real space by way of the media image. He embeds his projections in architecture, which he designs especially for the exhibition space. By mixing video, live performance, sets, and architecture, Mik creates an installation in which viewers themselves are caught in a flow of possible positions. The recipients see themselves as part of a theatrical performance. The cool setting provides no ideal point of view, but instead demands reflection on the self.

This special configuration of architecture, media image and the individual refers to a traditional line of inquiry within Video art. It goes back to the 1960s, when artists such as Dan Graham and Bruce Nauman confronted viewers with themselves in large video installations and multi-media, in situ works. Mik's *Parallel Bar* (1999) with its commingling of public space and live images represents a contemporary parallel to Graham's systems for urban forums, in which he juggles real and media images. Mik, however, considerably expands the field of action. For him the world is simultaneously a mass media network, an image and a copy, a stage, and a dangerous abyss for humanity.

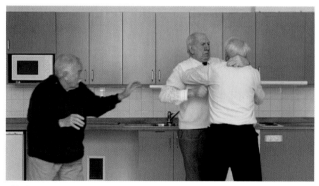

Kitchen, 1997

anthro/socio

Video installation (3 video projections, 6 monitors)

* 1941 in Fort Wayne (IN), USA

In the history of 20th-century art Bruce Nauman occupies an outstanding position with his complex and at the same time rigorous œuvre. In his videos and films, neon and cast works, installations and hanging objects, animal sculptures and photographs, the artist confronts the observer again and again with the essential conditions of life. He turns conventional patterns of perception on their heads, thereby provoking experiential reactions such as fear, distress, uncertainty, or fainting. Even early on Nauman used images and language together. In 1966 he composed the first word pieces, and in the following year he began to record performances on video.

In 1969 he created pure audio works when he rubbed a violin on the floor, subsequently tuned it to D, E, A, and D, and then recorded another tape. Nauman uses words and images beyond their inherent meaning, as a symbolic system. In this type of audio-visual media piece he is not striving to achieve a narrative form, but rather a structure that speaks directly to the viewer through its construction – as Nauman formulated it in his typical manner in *Anthro/Socio*.

Three large projections and six monitors, some of the monitors stacked upon each other, show differently framed shots of the bald head of a man – the Performance artist Rinde Eckert. Due to the radical cropping delimited by the screen's upper and lower edges, the head appears trapped within the rectangle of the electronic image. It spins continually on its own axis, and with the strained facial expression of a choirboy the man sings in different pitches "Feed me/eat me/Anthropology", "Help me/hurt me/Sociology", and "Feed me/help me/eat me/hurt me". The tone of the voice lies somewhere between aggressiveness and complaint.

Viewers must spatially surrender to the enervating acoustic presence of the words, and the powerful media images. They have no safe place in front of the work, but find themselves instead in the midst of the event. As in a stage play – the visible equipment stands in for props – they are assigned the role of protagonists. Viewers are at the mercy of the multiplicity and intensity of the heads – some of which seem mirrored and stand in turn "on their heads" – and the ritual, unvarying repetition of the contradictory words. These are absurd imperatives inviting viewers to feed the head, help it, eat it, and injure it. Although an intensive relationship between the recipient and the work exists, and is intensified by direct eye contact, the situation is not set up as a dialogue. On the contrary, images and words assail the viewers and besiege them. They therefore play the role of passive actors who are powerless to follow the requests, and who also cannot defend themselves against the urgency of the images and words.

In *Anthro/Socio* Nauman has melded various artistic means that he has used over the course of the years. Although he developed no video works between 1975 and 1985, in the video installation *Anthro/Socio* he allowed the performative approach from his early work, which emphasised physicality, to enter the piece – with heads standing on their heads – similar to the sculptural approach he takes with his cast-wax heads, which he has been creating since the end of the 1980s.

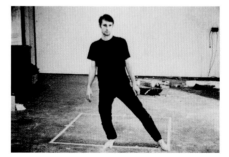

Dance or Exercise on the Perimeter of a Square
(Square Dance), 1967/68

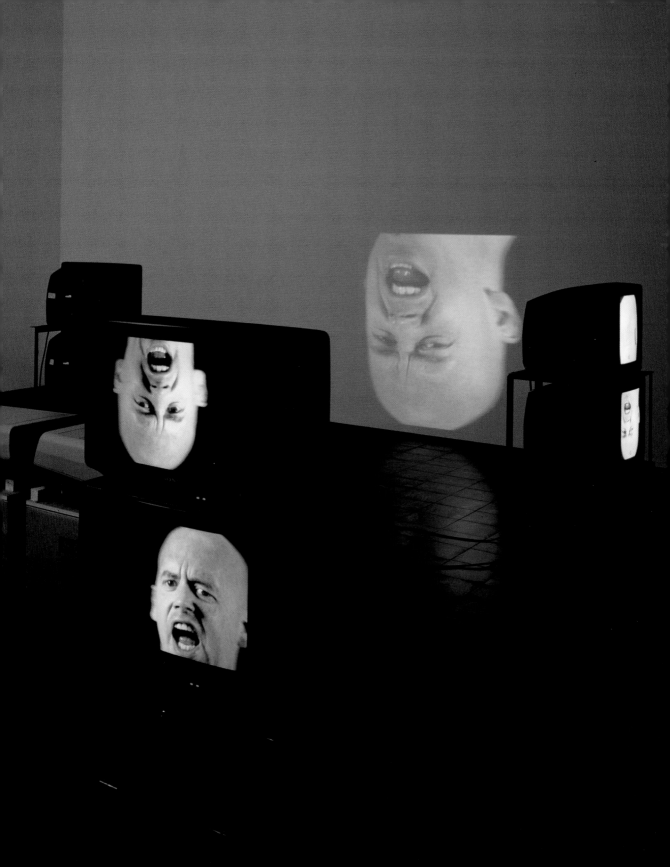

Fervor

2-channel video, black-and-white, sound, 10 min

* 1957 in Qazvin, Iran

Fervor is the final part of a trilogy that Shirin Neshat began in 1998 with *Turbulent*, and continued in 1999 with *Rapture*. The artist spliced impressive black-and-white film sequences together to provide a view of Islamic society. Her attention is thereby focused on the position of woman in Islam, and on religious, social and cultural codes that have their most obvious results in the spatial segregation of the sexes and in the wearing of the veil. In 1974 Neshat left Iran to study art in the USA. In 1979 the Islamic Revolution broke out, the Shah was overthrown, and many things changed. The new dictators demanded compliance with rigid religious guidelines, including the requirement introduced in 1983 of wearing a veil.

When Neshat travelled to Iran for the first time in many years, she was shocked by the socio-cultural changes. She created a series of black-and-white photographs entitled *Women of Allah* (1993–1997), showing women wearing the chador. They look directly at the viewers, whereby public eye contact between women and men in Islam is not actually allowed. They hold guns, and written on their faces, hands, and feet are provocative verses by Iranian poetesses.

In her films and videos, which she has made since 1996, Neshat continues her preoccupation with female identity in a religiously standardized society. In *Turbulent* she takes as her theme the dissimilar relationships of women and men to music: Islamic women are not allowed to make music in public. While obvious social differences between the sexes are open for discussion here, just as they are in *Rapture*, *Fervor* makes clear the way in which lastingly predefined behavioural patterns dominate every individual.

A meeting between two people at a desert crossing is played out on two adjacent screens. A woman veiled in the typical black robe and a man in a black "western" suit with a white shirt approach one another. The event is emphasized by the bird's-eye view from which the scene is shot. The emptiness of the space and the concentration on the protagonists creates an emotional tension – which comes to nothing, because there is no contact. The love story remains beyond the realm of experience due to the rigid religious code of behaviour. It continues in another scene, however, in which the code's power is clearly demonstrated.

The two protagonists appear at a public event. The audience is separated into female and male sections, strictly separated by a curtain. Once again the camera records the situation from an elevated position. A clergyman rails against sin and desire. The man and the woman make renewed eye contact, which betrays their passion for one another. The clergyman's words become more and more aggressive, and the restrained flirtation turns into an apprehensive and insecure emotional state. Finally the woman gets up from the multitude and leaves the room.

Neshat's pictorial language is symbolically loaded and full of pathos. She does not, however, propagate romantically glorified western ideas, such as those which have been distorting the view of the Arabian world for centuries. On the contrary, Neshat uses the superior strength of imagery to document how unshakeable the dominant code of behaviour in Islamic society is, and to allow outsiders to experience this.

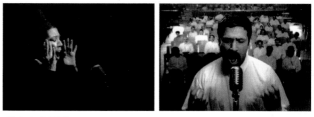

Turbulent, 1998

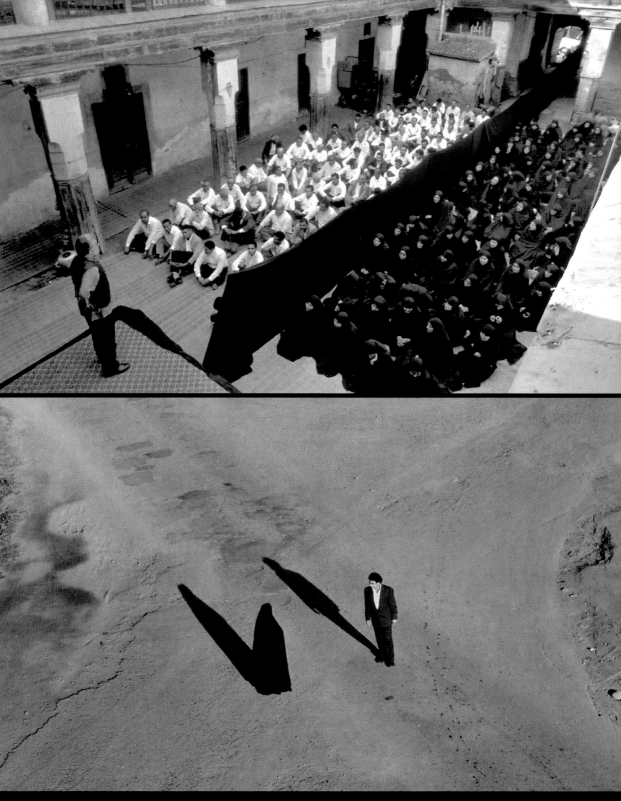

тHe ιdea of Africa

Video installation, 39 min

* 1953 in Cologne, Germany

The concepts of politics, history, identity, cultural areas, and seeing – the perception of the world through a camera lens – identify the central terrain that Marcel Odenbach critically manipulates in his videos and video installations. Odenbach is one of the most internationally well-known Video artists of the first generation, and was of central importance to the development of German Video art. Thus in 1981, together with the artists with whom he founded the group "video rebels", Ulrike Rosenbach, Klaus vom Bruch, and Rune Mields, he vehemently objected to the Cologne exhibition "Westkunst", described today as pioneering, in which Video art was almost completely overlooked. Something else may have displeased him about the exhibition's concept at the time: the exclusivity with which Western Art celebrated itself. In many of his works Odenbach – whether historically or biographically motivated – examines the relationship with non-European cultures.

The Idea of Africa is the product of a video workshop led by Odenbach in 1998 at the invitation of the Goethe Institute in Douala, Cameroon. He selected his pupils out of the crowd of people passing by. Camera in hand, the youths filmed their everyday lives and their cultural environment. Odenbach edited the material and presented it as part of the double-screen video installation, *The Idea of Africa*. Around 50 shots by workshop participants can be seen.

In the opening sequence a small African boy stands in front of the camera and looks directly into the lens. He then holds his hands in front of his eyes. This is followed by scenes in which men are shown at work or cleaning house. Children play on the dusty streets. A tapestry of images develops, which documents everyday life in Douala. Toward the end of the tape an African child approaches Odenbach and touches his hand.

The adjacent second screen shows historical footage from colonial times, documenting a procession on the occasion of the Ger-

man Consul's visit to the former German colony of Togo in the year 1913. Photos of everyday colonial life formed the framework for the ceremony. These showed members of white society taking tea or riding in their coaches. For these sequences Odenbach used found footage (already available audio-visual material) which he subsequently reworked.

The documentary images form a clear contrast, particularly because they are black-and-white, to the colour shots from 1998. A double perspective opens to the viewers: Odenbach contrasts the African video students' contemporary view of their own country and immediate socio-cultural environment with the historicizing gaze of Western Europeans, and here particularly of Germans, and their territorial approach to a strange culture. The confrontation of the different perceptions – on one hand, from within, looking at one's own culture (the video students) and on the other, from without, looking at the foreign (historical film) – makes clear how differently the question about one's own identity can be answered. "The idea of Africa" has many faces.

Dans la version péripherique du temoin, 1986

getaway # 2

Single-channel multi-media video installation

* 1957 in New York (NY), USA

Besides Bill Viola and Gary Hill, Tony Oursler is arguably the best-known American Video artist. His dolls, which appear to be living creatures but are made out of fabric, plus various other materials, technical hardware, and projected images, have conquered exhibition spaces internationally. They are video works somewhere between sculpture, performance – Oursler frequently works with the performer Tracy Leipold – and installation. Many situations are reminiscent of sets from theatre and film, in which besieged and disturbed people, societal misfits, give voice to their fate. Thereby in his installations Oursler uses simple objects and materials that are common in daily life and are sometimes also worn out, just as he did even in his early single-channel videotapes from the 1980s.

The humanoid creatures often exist only as head shapes, such as Judy in *Insomnia* (1996) who cannot sleep, or the creature supposedly under water and permanently gasping for air in *Underwater (Blue/Green)* (1995). The head never reaches the water's surface to actually breathe the oxygen essential for life. The despair of existences like these inevitably transfers itself to the viewer.

Oursler also pursues this strategy of mental annexation in *Getaway # 2*. Under a mattress lying on the floor and covered with an attractive floral pattern is wedged a head. Set up close to the scene, a small-format projector projects the film of a face and the mobile play of expressions on the head's oval form. The rest of the trapped person is made up of a limp, overly short piece of fabric forming the torso. The situation calls for sympathy and appeals to a viewer's readiness to help. Nevertheless, viewers keep their distance from the person, for the voice belonging to the head cries: "Hey, you! Get outta here!" This is followed by various obscenities and wild insults. Irresolutely and uncertainly the observer moves on, just as people on the street will pass by a homeless person who is talking to himself.

In *Getaway # 2* machines and man enter a symbiosis that cannot be dissolved. The face does not exist without the apparatus, and the device can make no statement if the projection does not appear. This complex interrelationship testifies to the mutual influence of the different perspectives of the human eye and the mechanical eye. Thus in Oursler's work processes of perception are just as much the subject of discussion as mental annexation.

With the technical equipment that is deliberately part of the work, Oursler is also always demonstrating the act of seeing. The artist even exaggerates this theme when, instead of a face, he projects only a single eye on a ball installed in a room as in *Eye in the Sky* (1997). Here the media gaze, the video with its entomological meaning of "I see", and man's natural organ of sight exponentially combine into a comprehensive understanding of perception.

In other works such as a control room (part of the installation *The Watching* (1993), which Oursler created at documenta 9), in which a feedback system is used, the topic of media perception once again disintegrates into its individual facets. For Oursler, however, it remains a fundamental element of which viewers must always be conscious for themselves.

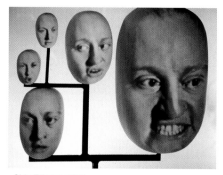

Side Effects, 1998

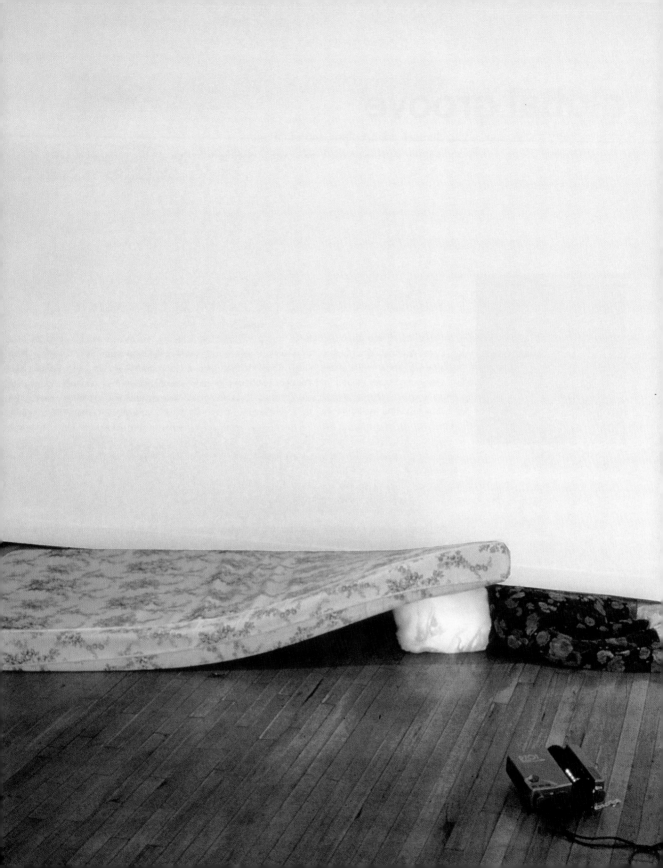

global Groove

Multi-monitor installation, single-channel video, colour, sound, 30 min

* 1932 in Seoul, Korea,
† 2006 in Miami (FL), USA

Even with his first exhibition "Exposition of Music – Electronic Television" (1963) in the Galerie Parnass in Wuppertal, Nam June Paik made video history by demonstrating on twelve prepared sets how manipulable the still-young mass media of television was. At that time Paik was working under the influence of the Fluxus movement. He moved to New York in 1964, where he became acquainted with the cello player Charlotte Moorman. Together they carried out numerous performances in which Moorman was "dressed" by Paik in video objects, or made music with such objects.

As early as the 1960s he created *TV-Cross*, his first multi-television video sculpture – a variation that reached its high point in 1988 when, on the occasion of the Seoul Olympic Games, he made a media tower consisting of 1003 monitors. Around 1970, together with the Japanese electrical engineer Shuya Abe, Paik developed a video synthesizer which allowed him to change the basic structure of the electronic image material. Parallel to this he began to experiment with the closed-circuit method, and in 1974 created one of his first sculptural feedback installations, entitled *TV-Buddha*.

The list of his innovative accomplishments could easily be continued, for example by mentioning the experiments Paik carried out with laser beams at the beginning of the 1980s. Originally, however, Paik trained as a musician and composer. A meeting with John Cage in Cologne in 1958 and Paik's work there in the radio station WDR's studio for electronic music, inspired him to create sound collages in which he combined various sound elements, noises, and classical music.

This collage principal can be seen again in video works like *Global Groove*. *Global Groove* was actually a government commission from the USA to promote international understanding, requested in the year 1971 when the Vietnam War had still not come to an end. Both visually and acoustically, Paik strung together 21 sequences

from different cultural areas, including both high and popular culture: two go-go dancers appear, a Navajo Indian sings and plays drums, Korean dances are performed, a black African is seen fist-fighting, and a Japanese commercial for Pepsi-Cola flashes by. Paik used material from public television stations just as he used excerpts from his own work, in which roles were played by some of his friends: John Cage, Charlotte Moorman, and the poet Allen Ginsberg. Eastern and Western Lebenswelten (life worlds), which Paik connects in his own life history, stand side by side. Some shots are additionally processed by a synthesizer. A portrait of U.S. president Richard Nixon seems completely distorted, while the media theorist Marshall McLuhan, in a shot taken from the work *McLuhan Caged* (1970), is also barely recognizable.

In *Global Groove* Paik plays with the structure of advertisements, the so-called clip-aesthetic, which was to be perfected at the beginning of the 1980s by MTV in its music clips. The quick progression of the sequences concentrates the audio-visual material into a pattern, the individual contents of which can only be comprehended with difficulty. Paik visualized a global synchronization, which would have both advantages and disadvantages. In his work with television and video Paik was always aware of this Janus-faced character of the medium. At the beginning of the videotape *Global Groove* a voice from off-camera announces: "This is a glimpse of a new world when you will be able to switch on every TV channel in the world and TV guides will be as thick as the Manhattan Telephone book."

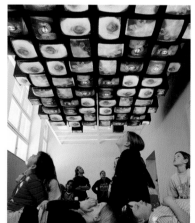

Fish Flies on Sky, 1985

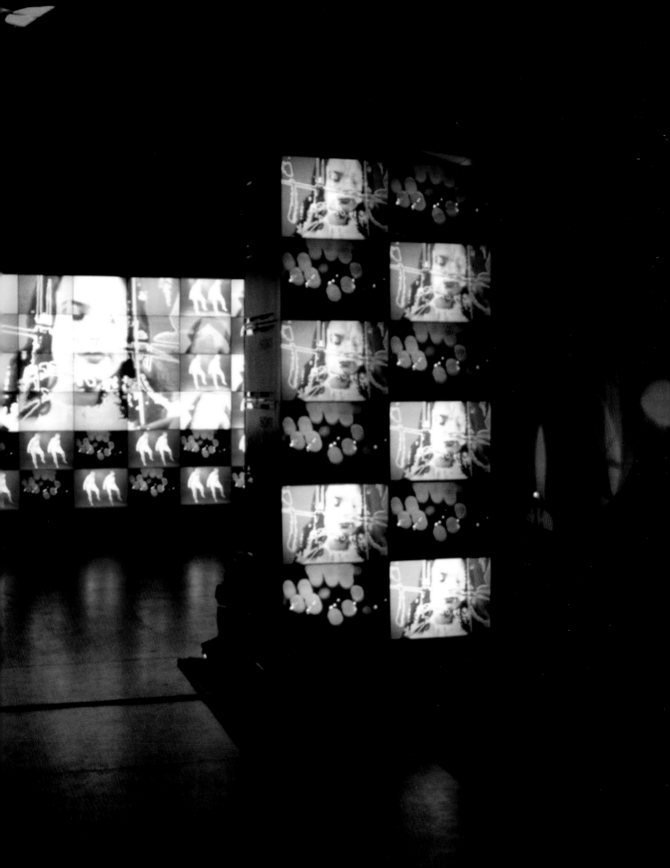

I'm Not the Girl who misses much

Single-channel video, colour, sound, 5 min

===

* 1962 in Grabs, Switzerland

One could describe Pipilotti Rist as the glamour girl among those young Video artists who have been working in a natural way with their femininity since the 1990s. Rist's works are attractive, suggestive, colourful, and musically memorable. She connects the whimsicality of media images with basic questions about sexuality, the female body, and sexual differences in today's society. With a gaze that is simultaneously humorous, ironic, and critical, she is tracing the unconscious processes that are ultimately responsible for so many behavioural norms and clichéd images.

In most of her videos the artist herself is the performer, as is also the case in *I'm Not the Girl Who Misses Much* which, although she created it while still studying, already contains significant elements of her work. In a black dress that leaves her breasts free, and wearing shrill red lipstick, Rist dances and contorts in front of the camera. The framing of the shots changes. In one sequence only a broadly grinning mouth is to be seen. The impression nevertheless prevails that the artist is acting in front of a static camera, as was usual in the early performance videos of the 1970s. Something else is reminiscent of the "old" video recordings: the pictures are out of focus, so that one's view of the dancer is obscured as if by a veil. The colour inclines towards the monochrome and seems artificial. Moreover, the speed of the images varies. It seems accelerated and then slowed down, and additional fades create further ambiguities.

The tape suggests poor quality, which in this case – as technical advancement had long since made perfect image-quality possible by 1986 – refers to the electronic construction of the video images. While Rist bounces about in front of the camera, she continually sings in a distorted voice: "I'm not the girl who misses much." This is the first line of the pop song "Happiness Is a Warm Gun" (1968) by John Lennon, whereby Rist derived the self-referential "I'm not the girl" from the original "She's not a girl".

The song was not only compressed, but its speed, as with the visual material, has also been manipulated. In Rist's video one line stands for an entire music clip. Toward the end of the clip the coloration changes from blue tones to a red one, and the song's original sound is heard.

In the song *I'm Not the Girl Who Misses Much*, Rist, who herself played in a band at the end of the 1980s, examines the mechanisms of the music industry, where mass production, the cult of the body, and voyeurism enter into a questionable alliance. Rist responds to this world by reflecting it: that is, by using pleasant, even beautiful pictures, and memorable soundscapes. Even when her miniaturized body seems in danger of sinking into a tiny flame-buffeted hole in the ground, as it does in the later video installation *Selbstlos im Lavabad* (Selfless in the Bath of Lava, 1994), and of disappearing at the same time into a flow of electronic impulses, the semblance of a beautiful electronic world is still maintained.

Selbstlos im Lavabad, 1994

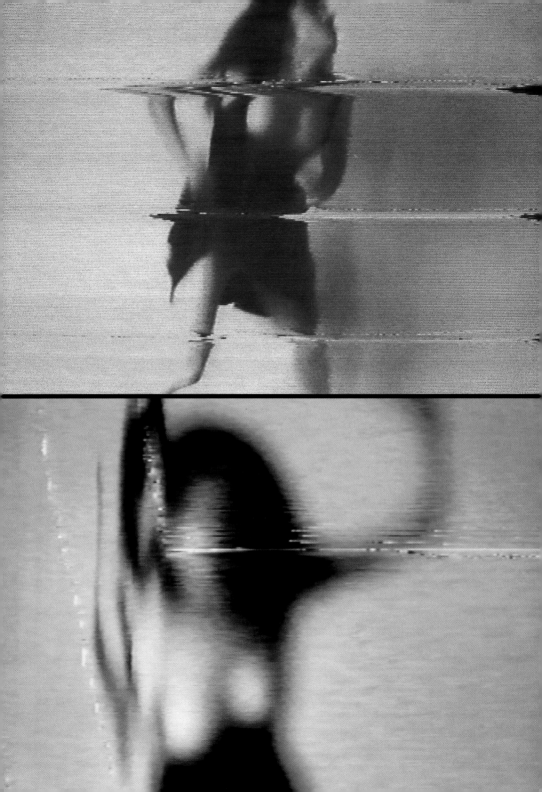

Born to Be sold: martha Rosler Reads the strange case of Baby sm

Single-channel video, colour, sound, 35 min 20 sec

==

*** 1943 in New York (NY), USA**

Although Martha Rosler began working with video in the mid-1970s, it would be incorrect to describe her as a Video artist. Rosler, who like many artists in the 1960s sought other means of expression as alternatives to painting, was interested in poetry, art, theatre, photography, and the films of the French director Jean-Luc Godard. She developed a multi-media practice that included textual work, collage, photography, installation, and performance. With this crossover, in which the media themselves are also always under discussion, and with the dedicated, critical gaze applied by Rosler to dissect political and social conditions, she was still a source of inspiration to a young generation at the turn of the millennium.

Around 1970 Rosler was working actively in the anti-war movement and was, as she herself says, a "nascent feminist". She studied at the University of California in San Diego, where the German philosopher and representative of the Frankfurt School Herbert Marcuse had been teaching since 1965.

The Bowery in Two Inadequate Descriptive Systems (1974/75) was one of Rosler's first outstanding works. Here she combined black-and-white photographs of business façades in New York's Bowery district with fragments of text. The photographs of business entrances document places where homeless people sought protection at night; these are the settings for an occurrence that is not present. Words distributed erratically upon the white pages describe, in colloquial terms, the condition of inebriated people. With the confrontation between photography and poetic word fragments, Rosler wanted to raise a question of central importance in the American history of photography: What distinguishes a documentary strategy?

Contemporaneously with the photo-text work, Rosler created the video *Semiotics of the Kitchen* (1975), in which she humorously caricatures the role of women as portrayed by the media. She herself steps before the camera wearing an apron with a serious expression on her face. As in many other performance videos of the 1970s, the lens defines the framing of the event. The protagonist begins to present kitchen utensils in alphabetical order from A to Z. The individual objects are shown to the audience with an aggressive or even frustrated gesture, so that inevitably the neurotic character of the "perfect television housewife" is felt, until finally Rosler begins wildly waving a knife about in the air.

Besides works in which Rosler massively criticizes wartime events in Vietnam, this combination of mass media and clichéd images of women is typical of her artistic concerns. Thereby she alternates again and again between humorous, factual, and even poetically romantic styles.

In 1988 using documentary television material, interviews, and performative elements, she produced the video collage *Born to Be Sold: Martha Rosler Reads the Strange Case of Baby SM*, which deals with the salability of the female body. The surrogate mother Mary Beth Whitehead bears a child created through artificial insemination for the Stern family, using sperm from Mr. Stern. S stands for Sarah, the name chosen by the physical mother, and M for Melissa, the name selected by the Stern family. Rosler, making full use of the technical possibilities of the time, plays the roles of the various participants and, in her well-known ironical and critical manner, demonstrates the absurdity of the power struggles. Her analysis shows how questions of class, political, and ideological systems govern a women's existence.

Semiotics of the Kitchen, 1975

ıntervista – Finding the words

Single-channel video, colour, sound, 26 min

*** 1974 in Tirana, Albania**

Starting with everyday items or familiar occurrences that he discovers in the streets of Tirana or Paris, at the beach, at the zoo, in church, or in the suburbs, Anri Sala develops his videos in an experimental style. He uses the camera as both an audio-visual writing and a dissection device, with which he investigates his subjects' intrinsic structures and reveals their psychological, political, or socio-cultural sides, or those related to perception theory or natural science. Sala's œuvre to this point therefore seems somewhat disparate. It stretches between two poles: one remains primarily documentary, as in *Intervista – Finding the Words*, and the other is aesthetically loaded, as in *Cymbal* (2004), in which the glittering and rhythmic appearance of a drum-set's cymbal tantalizes the human eye to the point of becoming unbearable.

Intervista was Sala's first artistic video. A roll of film that Sala discovered in an old chest led him back into his mother's past. At the end of the 1970s she was a dedicated activist in communist Albania. The roll of film contained documentary material from this period. It shows Sala's mother at a propaganda event beside high-ranking representatives of politics and society, and it contains an interview conducted with his mother. The historical images, however, were lacking their corresponding sound track – at the end of the 1970s image and sound were still being recorded with two separate devices. Sala's mother could barely recall anything about the event.

Sala began to search for the lost words that his mother had spoken in the interview. He met the man who had been responsible for the sound at that time, and who was now working as a taxi driver. He sought out the journalist who had conducted the interview, now an elderly man living in poverty. Various life destinies, and subjective and prevalent political images, weave themselves together in this private process of recollection. Finally Sala turned to a school for deaf-mutes, and they helped him reconstruct the soundless words. When he confronted his mother with her own propagandistic catchwords, she remained confused, concerned, and ultimately speechless. The artist finally ends the video with a close-up of his mother.

In *Intervista* Sala works with simple videographic means: the camera accompanies the artist throughout his efforts to reconstruct the words. The individual plot sequences are edited into a clear succession. Only the interspersing of historical found footage – propaganda and news material – creates further breaks with which Sala connects past and present, private and pubic. *Intervista* is a sensitive work in which Sala, using documentary means, makes inroads towards the creation of a type of subjective cosmology.

"ɴaybe ı am insisting on making visible things that ı find meaningful, which in our rush, we fail to appreciate, forget and let disappear."

Anri Sala

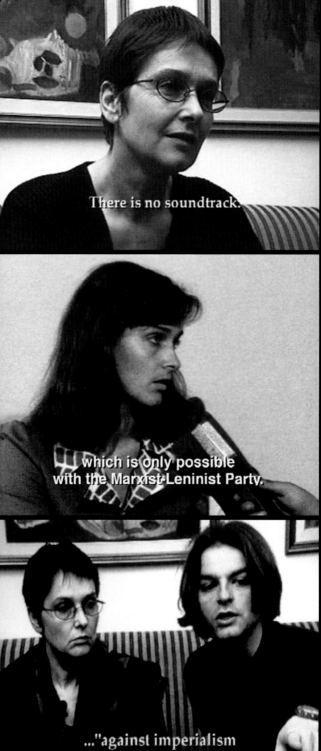

mouth to mouth

Single-channel video, black-and-white, sound

Stephanie Smith * 1968 in Manchester, UK; Edward Stewart * 1961 in Belfast, UK

The artists Stephanie Smith and Edward Stewart have been working as a pair since 1993 and, as in *Mouth to Mouth*, have been putting the relationship between the sexes to the test under extreme conditions. With their bodies, eyes, and mouths, they act out various roles in which the subtle power structures in a partnership are questioned. Their actions are not laid out in such a way as to cause the other pain, but injuries are by all means a possibility during the making of the works. In any event, the artists exhaust the possibilities of a situation to the point that they become unbearable.

In *Sustain* (1995) Smith produces numerous hickeys – bruises – on a male body with her mouth, while Stewart only uses his lipstick-covered mouth to leaves lip-prints on his female counterpart. To viewers both bodies appear to have been equally maltreated. The images in the video works of Smith/Stewart have a different effect on the public than do early performances from the 1970s, where Marina Abramovic and her partner Ulay, for example, overstepped boundaries again and again. With their live performances Abramovic and Ulay often caused themselves and the audience physical distress. Abramovic went so far as to injure herself, and occasionally this type of action had to be stopped to prevent the artist from getting into a life-threatening situation.

In *Mouth to Mouth* a man lies clothed in a bathtub filled with water. He is submerged. His eyes are open, his body rigid, and small bubbles climb to the water's surface from time to time. This is the moment in which the woman, initially only seen in cropped view as a figure next to the tub, becomes active. She bends down to place her mouth on the man's mouth, and supplies him with air to breathe. For the man, the woman's action is indispensable to life. He is dependent upon his partner and trusts her. Breathing can be tangibly experienced as an essential act. The bathtub forms a dominant diagonal in the projection. In this way the man forms the centre of the pictorial composition. When the woman leans over the man, she intersects the tub almost at a right angle. This compositionally compact entanglement emphasizes the connection between the partners.

In more recent work such as *Vent* (1998) or *Inside Out* (1997) Smith/Stewart go a step further. They assimilate the camera, and bodies and video begin to melt together. In *Vent* the viewer looks out of one of the actors' mouths. Rows of teeth border the electronic picture's upper and lower edges. The view from the mouth is of a white emptiness. With work such as these in which the performer and the performer's sex are no longer recognizable, Smith/Stewart place the body at the focus of their interest. Thereby they have expanded their initial topic, the relationship between the sexes, by adding the aspect of the body's interior and exterior. The composition of the video sequences now defines the body as the frame of the images.

Smith/Stewart act in front of the camera without an audience. They use video as a flexible medium, select image details that emphasize the action's intention, and work primarily with large projections, creating a realm of immediacy. The original sound and background noises are retained, and edited only with fade-outs and fade-ins. They exhaust the possibilities of the electronic medium of video, without attempting to produce artificial effects.

"we investigate the relationship between the sexes."

Smith/Stewart

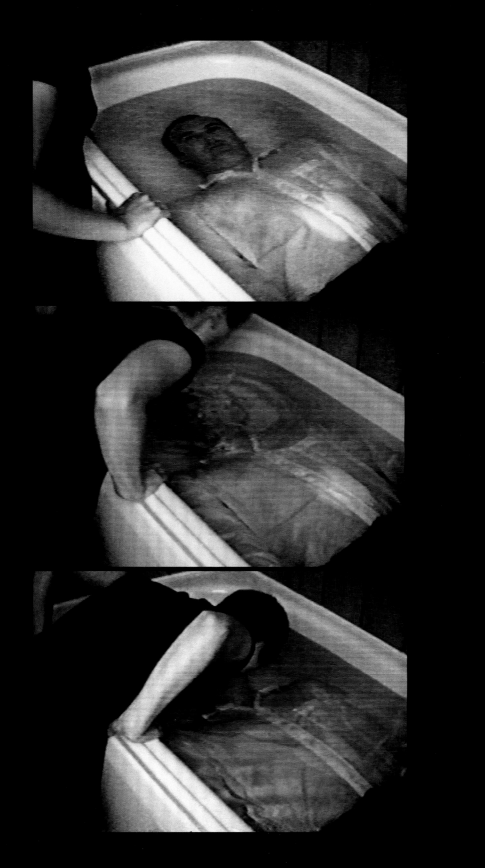

May You Live in Interesting Times

Film on DVD/digital Betacam, colour, sound, 60 min

* 1966 in Pekan Baru, Indonesia

A little monitor shows a cropped shot of the face of a woman – the artist herself. The device sits on a reflective surface so that the face is mirrored in it. It appears to be thinking about itself. The work bears the title *Portrait of the Artist as a Young Woman* (1995) and plays upon the novel by James Joyce "A portrait of the artist as a young man", which was published for the first time in 1944. In a biographical style and a factually narrative tone, Joyce describes a young man's arduous path towards finding his own identity, and the way that, in this process, he has to redefine the boundaries between himself and his family, and himself and the church.

Fiona Tan is also searching for identity, whether this be her own or that of another person. Born in Indonesia to a father of Chinese descent and an Australian-born mother descended from Scottish emigrants, Tan grew up in Australia. She studied art in Amsterdam, where she still lives today. In *May You Live in Interesting Times* Tan uses the camera to concretely pursue her family origins.

She starts the film logically by interviewing her parents, then traces her roots in the lives of aunts and uncles living in widely scattered places and under various living conditions as a consequence of the unrest in Indonesia during the 1960s. Thousands of people were killed during this period, including many Chinese immigrants. Tan's inquiries finally lead her to a little village in China, in which almost all the inhabitants bear her surname. She also makes yet another discovery: two of her uncles on her father's side apparently defended the Chinese minority in Indonesia, and as a result were imprisoned without trial for more than ten years. In conclusion, however, Tan can only state that the search for one's own identity is in vain: "I will never feel Chinese or Western … I have an identity defined only by what it is not … I am a professional foreigner."

Like Joyce, Tan also uses pictorial language that is realistic and clear. Over the course of two years she composed her biographical videotape by juxtaposing different documentary sequences about cities, individuals, and cultural circles, combined with shots of old photographs. In July 1997 Dutch television broadcast the film, and the private document became a public event that permitted insights into history, into the process of migration movements, and into the situation of today's society.

With her documentary and rational storytelling style, Tan opens up periods of time, changes perspectives, and presents the respectively "other" point of view, be it Western or Eastern. Thus in her works such as *Tuareg* (2000) she uses historical image material from the 1930s. This found footage shows children from Berber tribes, posing in front of the camera. Tan adds the sound of wind and other noises to the original black-and-white material, creating a new form of immediacy. Thereby the artist is interested in the question of identity among people who lived in a formal colonial region.

Tan generally presents her works in large installations. She puts the requisites of her media work on display by having large screens hung freely in the room, by projecting images on both sides of these screens, or by presenting the projection equipment as part of the installation.

> "I aim with this project [May You Live …] to investigate and hopefully deepen the current discussion of such hashed terms as: multiculturality, migration, and transgression."
>
> **Fiona Tan**

Home

Video-experiment, colour, sound, 16 min 47 sec

Steina Vasulka * 1940 in Reykjavik, Iceland; Woody Vasulka * 1937 in Brno (formerly Czechoslovakia, today Czech Republic)

When talking about the construction, alteration, and manipulation of electronically produced pitches, then Steina and Woody Vasulka must be mentioned as pioneers. Since 1969 they have been cooperatively researching the possibilities of the medium of video, which they see as a state of fluctuating energy and information. In dialogue with their electronic equipment and tools, with or without a camera, they design synthetic pictures that challenge conventional perceptions and create a consciousness of the world of signals and information. Both Steina and Woody Vasulka built upon previous knowledge, which led them to their structural approach in the field of video.

Steina previously studied languages and music at the music conservatory in Prague, and Woody attended both the Faculty of Engineering in Brno, and Prague's Film and Television Academy of Performing Arts. In 1965 they went to the USA together and were cofounders in 1971 of the legendary New York studio The Kitchen, where experiments were carried out with the new medium of video. Early experimental films of the 1920s and 1930s as well as innovations in the context of concrete music and poetry prepared the way, after 1945, for video also to be understood as semantic material.

The Vasulkas worked with different equipment and programmes, including the Rutt/Etra Analog Scan Processor, a dual colouriser, and a multi-keyer and switcher designed by the technician George Brown. An analogue scan processor allows the visualization of electronic signals by depicting the scan-line in wave format. The Rutt/Etra Scan Processor is additionally capable of depicting these lines three-dimensionally. The switcher simultaneously displays two different video sources in one sequence. Thereby the source material can be controlled separately.

Using these and other devices the Vasulkas created the technical prerequisites necessary for visualizing a wide vocabulary of electronic images. As the artists say, "We would rather make a tool and dialogue with it; that's how we belong with the family of people who would find images like found objects. But it is more complex, because we sometimes design the tools, and so do conceptual work as well."

The Vasulkas are basically Demiurges of an electronic world, which is founded on a mechanistic basis. Their pictorial surfaces assume the most varied of forms. Thus electronic snow, familiar to TV consumers only as interference, may be combined with geometric forms and blocked-out areas (*Noisefields*, 1974); or as in *Home* (1973), everyday objects like bottles, kettles, or apples may be transformed into projection surfaces for abstract patterns.

Here the Vasulkas present a balancing act between reality and electronic fiction, reminiscent of the imagined visual worlds of the surrealists. Thus the paintings of the Belgian René Magritte also inspired some of the two artists' electronic works. Thereby they renounce any connection to the real world and transform the electrical voltage into extended, folded, and compressed formations and volumes. The insurmountable area of conflict between one-dimensionality and three-dimensionality, essential to the medium of video, thus represents a constant challenge for the Vasulkas.

The West, 1983

I DO NOT KNOW
what it is I am Like

Single-channel video, colour, sound, 89 min

* 1951 in New York (NY), USA

Bill Viola is one of the international stars of the Video art scene. At the beginning of the 1970s he began to use complex temporal constructions such as *The Reflecting Pool* (1977–1979) to describe personal circumstances. Even in these first tapes Viola combined narrative and symbolic elements, inviting viewers to adopt a holistic point of view. Crucial to his work is his preoccupation with the mysticism of the Middle Ages. Viola was lastingly inspired by the spirituality of Hildegard von Bingen, Meister Eckhart, and Johannes vom Kreuz, as well as by Eastern mysticism such as Taoism, Zen Buddhism, and Sufism. The timeless and meditative screen sequences correspond in his media works to the vision beatific striven for by the mystics in the form of the unio mystica (union of the soul with God). The various compositions and choreographies in Viola's videos invite one to regard them contemplatively, and thereby to think about the nature of the world and of man. Following the ideas of the mystics, cognition should come about gradually in a series of steps.

Against this backdrop Viola continues to this day to incessantly surprise us with his impressive and atmospheric video work. In current installations such as *Emergence* (2002) he refers to familiar art-historical motifs – taken in this case from the iconography of the Descent from the Cross and the Resurrection of Christ. In composition and colouration the work is reminiscent of Italian masterpieces of early modern times, as created by artists such as Giovanni Bellini and Piero della Francesca. Viola uses digital processing to achieve an extreme slowing of plot, so that the video installation also represents reflection about the various media, the static image, and the animated video.

Taking the medium of video itself as a theme is a constitutive characteristic of Viola's work. In one of his central works of the 1980s, the videotape *I Do Not Know What It Is I Am Like*, important roles are played by light, darkness, vision, and the gaze, both in terms of the media composition as well as symbolically. For almost one and a half hours the artist weaves a tapestry of images out of various shots and motifs: landscapes, thunderstorms, and animals – including a freshly hatched chick and a bison – alternate with images of indigenous people, candles, and of the artist himself, who sits in his studio at night concentrating on his work and is thereby reminiscent of Jan Vermeer's painting "The Geographer" (1669).

In another sequence Viola focuses on the piercing eyes of an owl. He approaches the bird so closely that the camera and the cameraman can be made out in the black surface of its pupils. The world of technology and of man is reflected in the creature's eye. The artist also manipulates time in this epic story about the origins and state of the world.

Through extreme deceleration and acceleration Viola creates effects that break up the continuous pattern of images and attract the viewer's attention again and again. He uses completely black shots to produce an additional rhythm that brings into a single tempo his history of the world divided into five chapters – Il corpo scuro, The Language of the Birds, The Night of Sense, Stunned by the Drum, and The Living Flame.

Emergence, 2002

Broad street

5-channel video, film on DVD, 40 min

* 1963 in Birmingham, UK

Gillian Wearing uses photography and video as amplifiers. She is interested in that which remains unspoken, and in the wishes, suffering, and passions of people. Without any voyeuristic aftertaste the artist points the camera at herself and at others. The people she focuses on turn their innermost selves outward and use the electronic medium as a megaphone. Masks, disguises, or even the standardized behavioural patterns within a group can thereby offer protection, permitting a complete spiritual liberation. Under these conditions Wearing's work consists of a strange mixture of documentation, theatrical production, and everyday life. The question always arises of whether the viewed scenes are fake, "real", or both at once. An interplay between reality and fiction develops here, on both emotional and media levels.

In 1994 the artist filmed herself dancing uninhibitedly in a shopping arcade. This video, *Dancing in Peckham*, goes back to a situation that Wearing experienced in London's Royal Festival Hall. Here she watched a young woman who, while dancing to jazz music, had completely freed herself from her surroundings. The artist slipped into this woman's role and tested her own ability to abandon herself to the freedom of time and space. Less sensationally, passers-by in the photo series *Signs that say what you want them to say and not Signs that say what someone else wants you to say* (1992/93) formulated their wishes and worries by writing them down on a piece of paper and holding them in front of the camera.

While works such as these are concerned with the self, *2 into 1* (1997) shows an exchange of roles between a mother and her two sons. Wearing questioned the two eleven-year-old boys and the mother separately about their relationships to each other. In the video, however, the voices are exchanged: the mother speaks the answers of her sons, and vice versa. Wearing frequently works with changes like this in the soundtrack, sometimes also letting the tape run ahead or backwards.

In *Broad Street* (2001) Wearing follows the behaviour of teenagers who go out at night and consume large quantities of alcohol. In England drunken people, whether young or old, are part of everyday life on the street and in pubs. The state of drunkenness is far more socially acceptable there than in other countries, and under such conditions alcoholism is often not recognized. Wearing shows young people enjoying themselves on London's Broad Street in discos, pubs, and on the street, and thereby acting increasingly under the effects of alcohol. The sequences were filmed at night, and use only the light sources available. Diffuse chiaroscuro and, from time to time, a shrill and artificial flash of colour communicate an atmosphere in which excess can remain unnoticed, but where theatrical appearances in front of an audience may also be possible. Alcohol, imbibed by the entire group, plays the role of the mask here. It removes inhibitions and allows insecurities to vanish, until finally all control is lost. Bodies and spirits separate and have no more connection with each other, without them actually being able to renounce each other.

Thus Wearing takes as a theme one of the three areas of social interaction that particularly interested her in her previous work: beside individual social groups and their network of relationships, are individual people, their self-portrayals, and their families.

Dancing in Peckham, 1994

To stay informed about upcoming TASCHEN titles, please request our magazine at www.taschen.com/magazine or write to TASCHEN America, 6671 Sunset Boulevard, Suite 1508, USA–Los Angeles, CA 90028, contact-us@taschen.com, Fax: +1-323-463.4442. We will be happy to send you a free copy of our magazine which is filled with information about all of our books.

© 2006 TASCHEN GmbH
Hohenzollernring 53, D–50672 Köln
www.taschen.com

Editorial coordination: Sabine Bleßmann, Köln
Design: Sense/Net, Andy Disl and Birgit Reber, Köln
Production: Ute Wachendorf, Köln
Translation: Sean Gallagher, Berlin

Printed in Germany
ISBN 3–8228–2950–1

Copyright

Unless ot...
artists.
© for the
VALIE EX
VG Bild-K
© for the
© for the
© for the
a museum

Photo cr
The publis
galleries
making th
material f
named in
Courtesy
Courtesy
Courtesy
Bridgema
Courtesy
Deutsche
Courtesy
Courtesy
Courtesy
Courtesy
Courtesy
Courtesy
Courtesy
Courtesy
Courtesy
Courtesy
Courtesy
Paolo Pe

w York: p. 10, left
Courtesy Yvon Lambert, New York: pp. 62, 63
Courtesy Lehmann Maupin, New York: p. 25, left
Courtesy Lisson Gallery and the artists, London: p. 25, right; pp. 52, 53
Courtesy the artist and Metro Pictures, New York: pp. 76, 77
museum kunst palast, Düsseldorf: p. 78, below
Courtesy the artist and Galerie Christian Nagel, Köln/Berlin: pp. 82, 83
Courtesy Marcel Odenbach: pp. 74, 75
Courtesy Monika Oechsler: p. 22
Courtesy Maureen Paley, London: pp. 94, 95
Courtesy Galerie Eva Presenhuber, Zürich: pp. 32, 33
Courtesy Anthony Reynolds Gallery, London: p. 24
Courtesy Esther Schipper, Berlin: pp. 16, 50, 51
Schirn Kunsthalle, Frankfurt a. M.: p. 49
Staatsgalerie Stuttgart, Archiv Sohm, pp. 8, left and right (photo: Peter Moore)
Courtesy Galerie Barbara Thumm, Berlin: p. 7
Courtesy Steina and Woody Vasulka: pp. 12, 90, 91
Courtesy Bill Viola: pp. 4, 92, 93 (photos: Kira Perov)
Courtesy Galerie Barbara Weiss, Berlin: p. 23
Courtesy the artist and Donald Young Gallery, Chicago: pp. 2, 56, 57
Courtesy David Zwirner Gallery, New York: p. 17, right (photo: Margherita Spiluttini); p. 20 (and Courtesy of the Estate of Gordon Matta-Clark), 44, 45

Reference illustrations:

p. 26: Marina Abramovic, *Thomas Lips*, 1975, performance / p. 28: Vito Acconci, *Following Piece*, 1969, black-and-white photographs with text and chalk, text on index cards, mounted on cardboard, 76.8 x 102.2 cm, framed / p. 30: Eija-Liisa Ahtila, *If 6 Was 9*, 1995, 35mm film and DVD installation for 3 projections with sound chairs and sofa, 10 min. / p. 32: Doug Aitken, *Monsoon*, 1995, colour film transferred to single-channel digital video, sound, 6 min / p. 36: Candice Breitz, *Mother + Father*, 2005, two 6-channel video installations, colour, sound: *Mother*: 13 min 15 sec, *Father*: 11 min / p. 40: Peter Campus, *Three Transitions*, 1973, single-channel video, colour, sound, 4 min 53 sec / p. 42: David Claerbout, *Kindergarten Antonio Sant'Elia, 1932*, 1998, video projection on DVD, mute, black-and-white, 10 min / p. 46: VALIE EXPORT, *Tapp- und Tastkino*, 1968, Tapp- and Tastfilm, mobile film, real women's film, body action, social action / p. 50: Dominique Gonzalez-Foerster, *Central*, 2001, colour film, 35mm, sound, Dolby SR, 10 min / p. 52: Douglas Gordon, *Psycho Hitchhiker*, 1993, black-and-white photograph, 46 x 59.5 cm / p. 56: Gary Hill, *Windows*, 1978, video, black-and-white, colour, silent, 8 min / p. 58: Nan Hoover, *Light Poles*, 1977, video, black-and-white, sound, 8 min / p. 60: Pierre Huyghe, *This is Not a Time for Dreaming*, 2004, live puppet play, Super-16mm film transferred to Digi/Beta, colour, sound, 24 min / p. 64: Paul McCarthy, *Whipping a Wall and a Window with Paint*, 1974, video, black-and-white, 2 min / p. 66: Bjørn Melhus, *No Sunshine*, 1997, video, colour, sound, 6 min 15 sec / p. 68: Aernout Mik, *Kitchen*, 1997, video installation / p. 70: Bruce Nauman, *Dance or Exercise on the Perimeter of a Square (Square Dance)*, 1967/68, 16mm film, black-and-white, sound, 10 min / p. 72: Shirin Neshat, *Turbulent*, 1998, production stills / p. 74: Marcel Odenbach, *Dans la version péripherique du temoin*, 1986, video, black-and-white, colour, 13 min 33 sec / p. 76: Tony Oursler, *Side Effects*, 1998, Sony CPJ 200 projector, videotape, VCR, polystyrene foam, paint, steel stand, performance by Tracy Leipold; ca. 177 x 61 x 36 cm (plus equipment) / p. 78: Nam June Paik, *Fish Flies on Sky*, 1985, 88 monitors, 2 videotapes, installation view museum kunst palast, Düsseldorf / p. 80: Pipilotti Rist, *Selbstlos im Lavabad*, 1994, audio-video installation, Collection Hoffmann / p. 82: Martha Rosler, *Semiotics of the Kitchen*, 1975, video, black-and-white, sound, 6 min 9 sec / p. 90: Steina and Woody Vasulka, *The West*, 1983, electro/opto/mechanical environment by Steina Vasulka, audio by Woody Vasulka, two video, four audio channel installation, 30 min / p. 92: Bill Viola, *Emergence*, 2002, video installation / p. 94: Gillian Wearing, *Dancing in Peckham*, 1994, DVD for projection, 25 min

page 1
NAM JUNE PAIK

Video Flag X
1985, 84 10-inch TV sets, videotapes and plexiglass
Detroit, The Detroit Institute of Arts. Founders
Society Purchase; Lila and Gilbert B. Silverman Fund

GARY HILL

Tall Ships
1992, installation (b/w, silent), 16 modified 4-inch b/w monitors with projection lenses, 16 laserdisc players, 16 laserdiscs, computer with 16 RS-232 control ports and pressure-sensitive switching runners, black or dark grey carpet, controlling software, dimensions of corridor: 3 x 3 x 27 m

page 4
BILL VIOLA

Nantes Triptych
1992, video/sound installation

Made in the USA
Charleston, SC
21 January 2016

5143516^{7R}00104